IMAGES
of America

DOWNTOWN
PASADENA'S
EARLY ARCHITECTURE

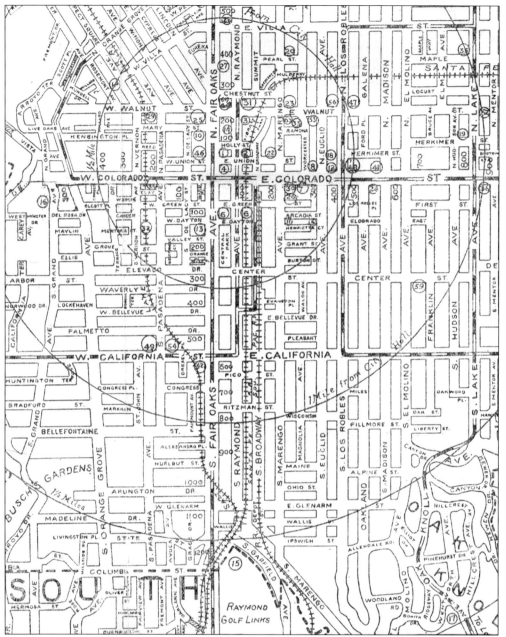

A 1912 map of Pasadena's downtown shows the main intersection at Colorado Street and Fair Oaks Avenue, Orange Grove Avenue on the west, and Lake Avenue on the east. Raymond Hill, the location of the Raymond Hotel, is at the bottom of the map. The Atchison, Topeka & Santa Fe Railroad, the Los Angeles & Salt Lake Railway, and the Southern Pacific line are all shown on the map, as are the streetcar lines on the main streets.

ON THE COVER: Pasadenans gather on Colorado Street to celebrate the incorporation of the Los Angeles & San Gabriel Valley Railroad in 1883. This view looks west on Colorado toward the main intersection at Fair Oaks Avenue and Colorado Street, known as "The Corners."

IMAGES
of America

DOWNTOWN PASADENA'S
EARLY ARCHITECTURE

Ann Scheid

ARCADIA
PUBLISHING

Published by Arcadia Publishing
Charleston SC, Chicago IL, Portsmouth NH, San Francisco CA

Printed in the United States of America

Library of Congress Catalog Card Number: 2005927056

For all general information contact Arcadia Publishing at:
Telephone 843-853-2070
Fax 843-853-0044
E-mail sales@arcadiapublishing.com
For customer service and orders:
Toll-Free 1-888-313-2665

Visit us on the Internet at www.arcadiapublishing.com

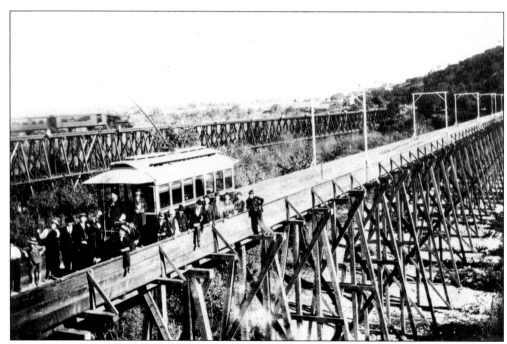

The first electric streetcar reached Pasadena from Los Angeles in 1895. This picture shows it on the trestle built across the Arroyo Seco near Garvanza (now Highland Park). (Courtesy Security Pacific Collection, Los Angeles Public Library.)

CONTENTS

ACKNOWLEDGMENTS

When asked to write this book, I realized that this format could introduce a wider audience to the findings of Pasadena's architectural survey, begun in the late 1970s. To tell the story of how downtown grew and changed, I searched for photographs in many libraries. Some I had hoped to find did not exist, but I discovered so many others that it was difficult to choose among them. Research online in the archives of the California State Library in Sacramento, the Los Angeles Public Library, and the University of Southern California turned up many photographs, as did research at the Seaver Center at the Los Angeles County Museum of Natural History. I owe a great debt to all of the librarians and volunteers who generously helped me in my search: at the California State Library, Dawn Rodrigues, Vickie Lockhart, and Gary Kurutz; at the Seaver Center, John Cahoon; at the Los Angeles Public Library, Carolyn Cole, curator of the photograph collection, and her volunteers who helped catalog the collection; at the University of Southern California, my colleagues Dace Taube, Matt Gainer, and Claude Zachary; my friend, fellow historian and urban planner Paul Secord, who digitized photographs too large to fit on my scanner; and finally, my boss, Ted Bosley, director of the Gamble House, who has been unfailingly supportive. I owe a great debt of gratitude to the late Megs Meriwether, whose research in the Pasadena newspapers provides the sound basis for my own research on Pasadena's built environment.

Most of the photographs in this book come from the collection of the Pasadena Museum of History unless otherwise credited. Very special thanks go to museum director Jeanette O'Malley and her staff, Lian Partlow, Steve Tice, Kirk Myers, Julie Stires, Melisa Dragoo, Jon Sher, John Knuth, Brad MacNeil, Diane Siegel, Mary McIlwain, and Ardis Willwerth, as well as museum volunteers Bob Bennett, Jim Kendall, and Lynn Emery.

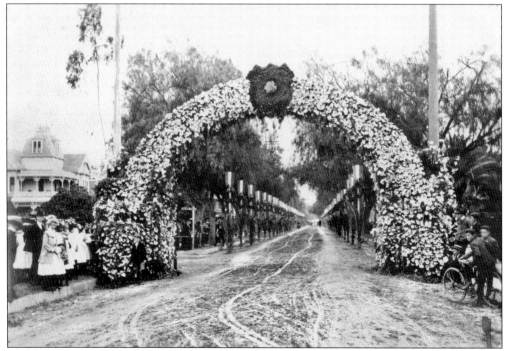

Pasadenans stand proudly beside the arch of calla lilies built over Marengo Avenue for the visit of Pres. Theodore Roosevelt in 1903. Atop the arch is a photograph of the president, an ardent conservationist who urged preservation of the Arroyo Seco.

INTRODUCTION

Pasadena's founders, dreaming of a bucolic life in sunny Southern California, banished all commercial establishments from their residential neighborhood along Orange Grove Avenue. Settled largely by a group of colonists from Indiana in 1874, early Pasadena began as a suburb, avoiding the organic growth of normal communities, with town centers surrounded by streets of houses. Pasadena's first store went up at the eastern boundary of the settlers' land, on Colorado Street on the east side of Fair Oaks Avenue, establishing the future business district over half a mile from the main residential street. Eventually, profit-minded property owners sold off small parcels at the edge of their acreages for business buildings, and so downtown grew north, south, east, and to a lesser extent, west of The Corners, as the intersection of Fair Oaks Avenue and Colorado Street came to be known.

The railroad reached Pasadena in 1885, and soon after, Pasadena and Los Angeles were connected to Chicago by rail. Fierce competition among the railroads, offering fares as low as one dollar to Southern California, set off a land boom in 1886. Eager to cash in on the escalating land values, Pasadenans auctioned off several acres of school property, prime commercial land on the southeast corner Fair Oaks Avenue and Colorado Street, ensuring the latter's role as the main street. Within a few years, Pasadena's commercial center grew from a few scattered wooden buildings to several blocks lined with substantial brick buildings.

The Raymond Hotel, with its 200 rooms, also opened in 1886 on a hill south of town. Other accommodations were not far behind: the Carlton Hotel downtown on Colorado Street in 1886, the Painter Hotel on a hill north of town in 1888, and the Hotel Green downtown in 1891–1893. By 1900, these grand hotels had secured Pasadena's reputation as a resort for the wealthy. Part of the attraction was its dry, clear air, believed to cure or prevent tuberculosis, a scourge associated with city life and lack of active exercise in fresh air.

Downtown expanded eastward along Colorado, stimulated by the presence of the Hotel Green, and south along Raymond Avenue, where the railroad station was located. Growth along Fair Oaks Avenue to the north remained limited to smaller business buildings. South Fair Oaks Avenue was for many years the main route to Los Angeles, but its proximity to the railroad tracks on the west limited its growth to service and industrial uses. The public library and Throop Polytechnic Institute were two major cultural institutions located on North Raymond Avenue, where a commercial district developed in the two blocks north of Colorado. Raymond became an important thoroughfare connecting three hotels—the Raymond, the Painter, and the Green—to the depot.

Marengo Avenue, on a high ridge parallel to the original Orange Grove settlement, began as a street of substantial residences. Eastward expansion of the business district, however, made Marengo and Colorado a commercial intersection by the early 1900s. Initially Marengo and the neighborhood east of it attracted some of Pasadena's large churches. Large school buildings, including Pasadena High School, which opened in 1904, were concentrated on Walnut Street between Marengo and Los Robles Avenue.

The Maryland Hotel, opening in 1903 on East Colorado, and a new post office in 1914, just two blocks west of the hotel, attracted new shops to the area. By the mid-1920s, the Maryland was the center of Pasadena's fashionable shopping district.

Older residences were demolished to make way for new commercial buildings as downtown expanded. At its edges, especially to the north, south, and west, were artisans, services, and supply businesses. To promote itself as a fashionable resort, Pasadena advertised its aversion to industry; yet the city required a certain amount to function. In 1914, the city passed an ordinance governing the industry south of Central Park. This area along the railroad tracks was to be beautified by landscaping and quality architecture, especially to improve the view from passing trains. Although the ordinance was apparently never enforced, many laundries locating there built architecturally distinguished buildings set back from the street behind lawns and trees.

Pasadena's beautification efforts culminated with the civic center plan in the early 1920s. Conceived by experts from Chicago and promoted by local leaders, the plan called for three major public buildings—a library, city hall, and auditorium—each terminating a major axial boulevard. Chosen by competition, the architects of these new civic structures were to seek inspiration from the architecture of the Mediterranean. Other new buildings that joined them also conformed to the prevailing style. While many cities proposed similar plans, Pasadena is unusual in that the plan was actually realized.

The opening of the Colorado Street Bridge in 1913 stimulated growth along West Colorado. Colorado was already part of the national highway system, eventually called Route 66, a major artery into Southern California from the east. While the city had long discussed widening Colorado through the old downtown, it finally happened in 1929, requiring owners to move existing buildings back 14 feet. New facades in the popular art deco, Spanish Colonial Revival, or Mediterranean styles replaced old Victorian fronts, and gave Colorado, which was losing business to competitors in the popular Maryland Hotel district, a facelift. Although prominent architects suggested that the new facades conform to the style of the civic center to give Pasadena a dominant architectural theme like Santa Barbara's, the idea was never carried out.

The 1930s brought the Great Depression and a decline in tourism. The Maryland, the Raymond, and the Green hotels closed, depriving the city of the mainstay of its economy. In the 1960s, the city embraced urban renewal and redevelopment, ignoring its architectural heritage and destroying in the process many important assets. In the 1970s, Pasadena began a survey of its historic buildings, focusing first on what was left of its original downtown around Fair Oaks Avenue and Colorado. Miraculously, many of the buildings survived, thanks to the resistance by owners to proposed redevelopment. The district was listed on the National Register of Historic Places, and in 1981, the city passed an ordinance protecting the buildings in the area known as Old Pasadena. At the same time, Pasadena Heritage successfully spearheaded an effort to list Pasadena's civic center on the National Register, thereby restoring it to the collective memory and promoting its preservation. Old Pasadena is a thriving commercial district once again, and many of its building have been restored as restaurants, shops, and theaters.

Most inspiring is the restoration of the Colorado Street Bridge in the 1990s. Crumbling from exposure to weather and no longer needed to carry traffic, the bridge that was called "a work of art" when it was built was in danger of demolition. Pasadena's city government, Pasadena Heritage, and expert engineers worked together using state and federal funds to make one of the city's most beautiful landmarks whole again.

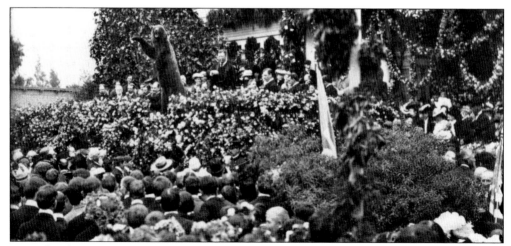

Pres. Theodore Roosevelt visited Pasadena in 1903. This photograph shows him (to the right of the bear) speaking to a crowd in front of Wilson School.

One

THE CORNERS

Pasadena's setting at the foot of the San Gabriel Mountains and on the edge of the ravine called the Arroyo Seco both promoted its growth and limited its development. The mountains and the Arroyo imposed physical barriers to expansion, yet their dramatic beauty drew settlers and tourists alike. The semiarid grazing land had access to plentiful water from the Arroyo and from wells, which appealed to newcomers dreaming of orange groves and vineyards. Native sycamores and willows grew in the Arroyo, and small canyons along the southern edge of the town, and isolated native oaks dotted the upland pastures or clustered in groves near the canyons, where their deep roots found more water. The earliest downtown buildings at Colorado Street (now Boulevard) and Fair Oaks Avenue, known as The Corners, were simple wood-frame structures, probably not so different from the earliest houses in the heart of the settlement along Orange Grove Avenue, over half a mile away. Built of vertical redwood boards with battens covering the joints, these simple, single-wall buildings were so characteristic that they were later referred to as "California construction." Redwood came from the vast forests of Northern California, first by ship and, after 1876, by rail.

The most important building of Pasadena's first decade was the schoolhouse, built in 1878 on five acres at the southeast corner of The Corners. A two-story, wooden structure with eight classrooms, one for each grade, the new grammar school was in the form of a Greek cross, its projecting wings giving classrooms natural light from two directions. The style followed the popular vogue for Italianate architecture of the period, with heavy applied decoration around the top of the windows forming "eyebrows." The schoolhouse was the work of Hamilton "Harry" Ridgway, just arrived from Canada and destined to become Pasadena's first important architect. Like many of his Victorian peers, Ridgway was trained in the profession by apprenticing in an architectural office, probably in his native land. When he arrived in Pasadena, he was clearly an accomplished practitioner. Ridgway would go on to design many of Pasadena's large business buildings, churches, and houses through the 1890s.

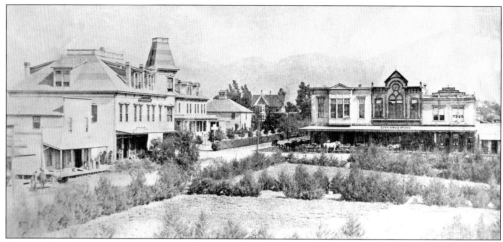

A major landmark of the business center (pictured looking northwest in the early 1880s) was the Ward Block (with tower), located on the southwest corner of Colorado Street and Fair Oaks Avenue. Behind it, on the northwest corner, was the Angeles House hotel (with veranda). To the right, on the northeast corner, is the general store, originally built by L. D. Hollingsworth in 1876 (no photograph survives), and two other two-story frame buildings. The landscaped foreground is part of the schoolhouse lot on the southeast corner.

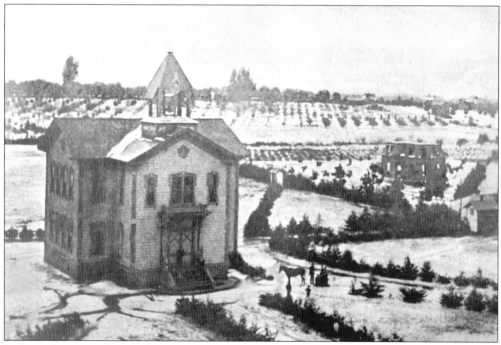

Built on five acres donated by Benjamin Wilson, who had sold the settlers their land, Central School was the largest building in the downtown when it went up in 1878. Designed by architect Hamilton "Harry" Ridgway, the two-story building was outfitted with a bell tower and bell to call the pupils to class. Behind the school was the outhouse, visible to the right of the building in this rare photograph taken after a snowfall in 1884.

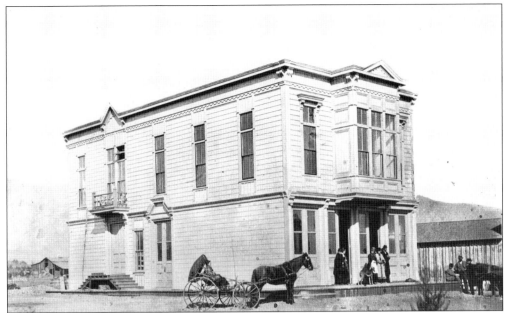

Romayne "Barney" Williams was a penniless young man when he arrived from New York in 1877, but by 1880 he had acquired the general store. Williams built this new two-story building designed by Harry Ridgway in 1883; it also housed the post office and had a meeting hall on the second floor. In December 1883, Williams installed Pasadena's first telephone in the store. The first words spoken into the phone were reportedly, "He isn't here."

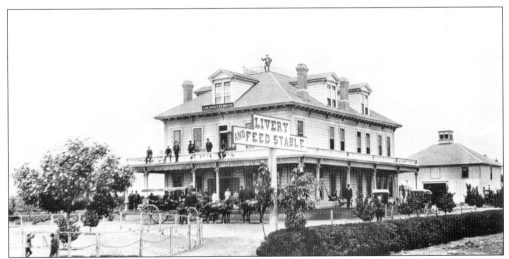

Isaac Banta, a settler from Ohio, built the Los Angeles House hotel on the northwest quadrant of The Corners in 1883. A large barn behind the hotel housed carriages and horses. In 1886, the hotel was moved one block west to the corner of DeLacy Avenue and Colorado to make way for the First National Bank's new brick building.

This view east on Colorado Street in 1882 shows groves of young orange trees and scattered frame farm buildings. (Photograph by T. G. Norton.)

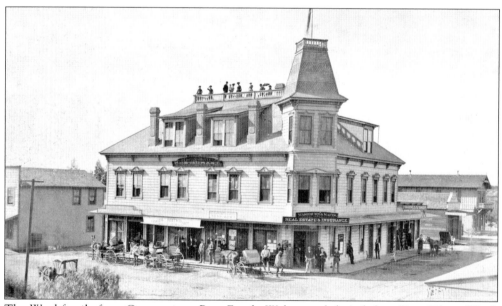

The Ward family from Connecticut, Ben, Frank, Walter, and their father, Gen. Edwin Ward, built an imposing two-story building with a tower on the southwest corner of Colorado and Fair Oaks Avenue in 1883. The building housed the Grand Hotel and the Wells Fargo Express office. The Wards also founded Pasadena's first newspaper, the *Pasadena Chronicle*, in 1883. (Photograph by T. G. Norton.)

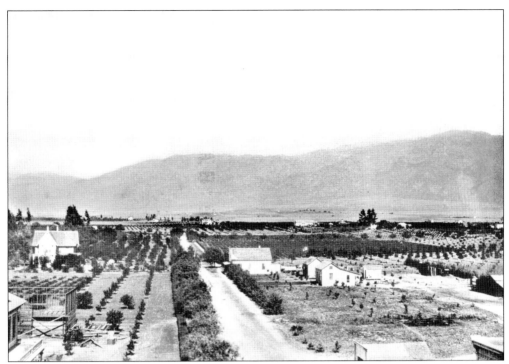

Viewed from the tower of the Ward Block, Fair Oaks Avenue leads north toward the mountains. On the far left, the livery barn for the Los Angeles House is under construction. Behind it is Benjamin Franklin Ball's house, the first brick building in town, designed by Ridgway and known as "Valley Grange." Pasadena had no brickyard in 1879, so the bricks were hauled by wagon from Los Angeles.

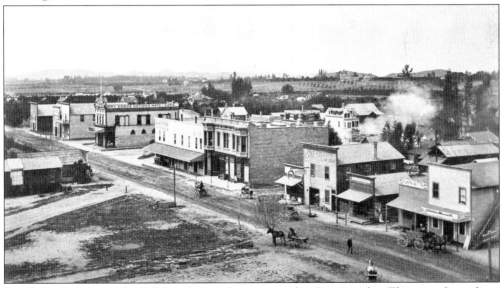

Fair Oaks Avenue south of Colorado was the main road to Los Angeles. This view from about 1886 shows several frame buildings and even one brick building. Small hotels, livery stables, a carriage works, groceries, a tailor, a tin shop, a locksmith, a clothing store, a dry goods store, and a restaurant lined the west side of the street. (Photograph by E. S. Frost and Son.)

13

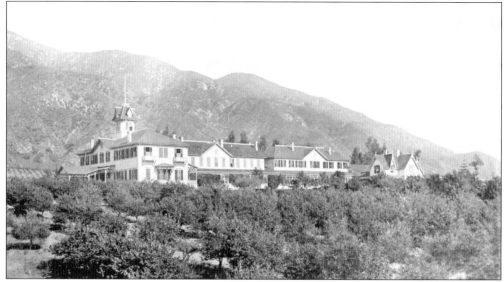

The Sierra Madre Villa Hotel opened in 1877, a year after the first railroad reached Southern California. It began as a cottage built in the foothills above present-day Sierra Madre by William Porter Rhoades of the state of New York. Bored with ranching, Rhoades decided to open a hotel. His gregarious personality suited him to the business that attracted sophisticated guests with a taste for adventure and the outdoor life. (Photograph by T. G. Norton.)

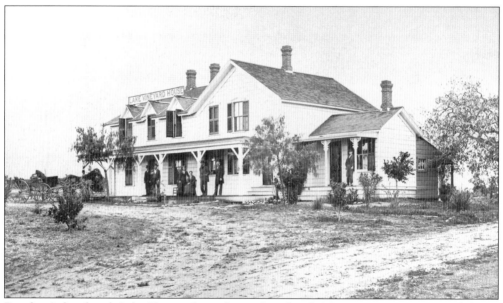

Pasadena's first hotel, Lake Vineyard, was located on South Marengo Avenue near California Street. Built in 1879–1880 by a Mr. Griswold, it was sold to Isaac Banta in 1882. Despite its fine views, it failed to prosper because it was too far from The Corners at Colorado and Fair Oaks Avenue. The hotel ceased operation, becoming a private home in 1885. (Photograph by Watkins Photo, San Francisco.)

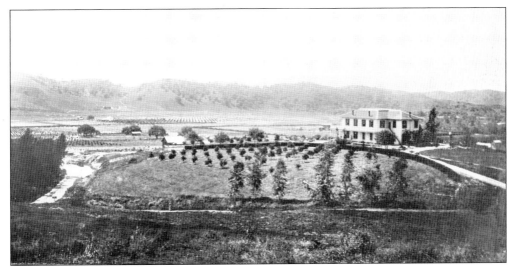

The Hermosa Vista Hotel on Columbia Hill opened its doors in 1882. Eventually the building was converted to a residence and became the home of astronomer George Ellery Hale from 1908 through 1936. The house was demolished in 1953 to make way for a subdivision.

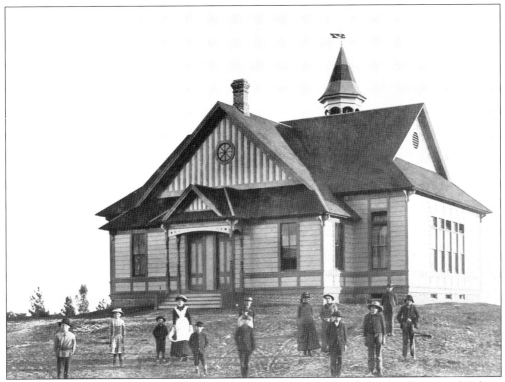

Pasadena's first college, Sierra Madre College, opened in 1885 at Columbia Street and Sylvan Drive. Although many prominent citizens were involved in its organization, the college failed after only two years, because "it was mislocated, was premature, was not on a plan in touch with the spirit of the times, and had no money behind it," according to an early historian. C. D. Daggett later converted it to his residence.

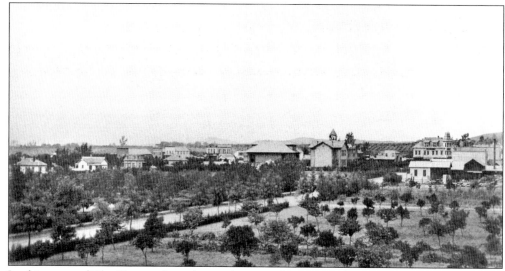

Looking toward The Corners from the northeast in about 1884, the two-story library building is in the center of the picture, just to the left of the schoolhouse with its bell tower. Built by Clinton B. Ripley for $2,300 in 1883–1884, Library Hall was painted red and green. The lower story served as the library; the second story was a meeting hall used by various fraternal orders.

A similar view shows a scene after the arrival of the railroad in September 1885 but before Library Hall and the schoolhouse were moved in 1886. (Photograph by C. U. Bunnell.)

Two

THE RAILROAD ARRIVES

The land boom set off by the arrival of the railroad in 1885 caused rapid expansion of Pasadena's downtown. The railroad's location, running north and south through the business district between Raymond Avenue and Broadway and curving to the east, north of Walnut Street, would have lasting effects on the development of Pasadena.

The opening of the Lake Vineyard tract east of Fair Oaks Avenue in 1876, subdivided into small parcels in a rigid, regular grid, set the pattern for downtown growth and for most of Pasadena's future development. The first settlers with their large acreages had planned their major street, Park Avenue (later Orange Grove), to follow roughly the natural contour of the edge of the Arroyo Seco, ending in a park with a reservoir on the Arroyo bluff. The street featured small, landscaped parks down the center to preserve the live oaks. This response to nature was abandoned with the adoption of the grid, signaling that Pasadena would follow the conventional pattern of most American cities.

Initially seen as a boon, the railroad line attracted hotels such as the Hotel Green to locate nearby, going so far as to build a station for the Santa Fe line behind the hotel. Expensive shops located along Raymond Avenue next to the railroad. The public library and both of Pasadena's parks were close to the line. In later years, however, proximity to the railroad had a negative influence, contributing to the deterioration of the downtown and nearby residential neighborhoods. The east-west route through town created a division between north and south, which became even greater with the railroad's replacement by the 210 Freeway in the 1970s.

The Raymond Hotel, isolated on its mount south of town, also built its own railroad station to attract visitors. Anticipating the arrival of the railroad, Walter Raymond began construction of his hotel in 1883. The son of one of the original 40 stockholders of the Santa Fe, Raymond had more than faith to guide his decisions. When the Raymond opened at the end of 1886, it was poised to take advantage of the tourists arriving on the Santa Fe line who were eager to explore the newly accessible Southern California region.

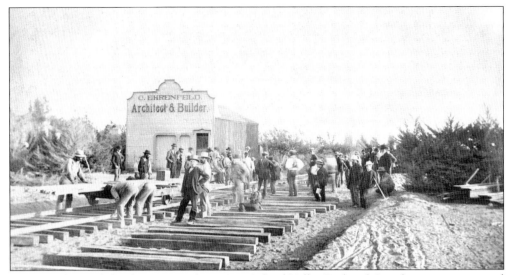

Workmen lay track for the Los Angeles & San Gabriel Valley Railroad. Pasadena investors raised a total of $350,000 in 1883 to finance construction. Despite delays and financial reverses, the company completed a high bridge over the Arroyo Seco and received its first locomotive from Cincinnati in the summer of 1885, readying the line for opening in September. (Photograph by Martin Behrmann.)

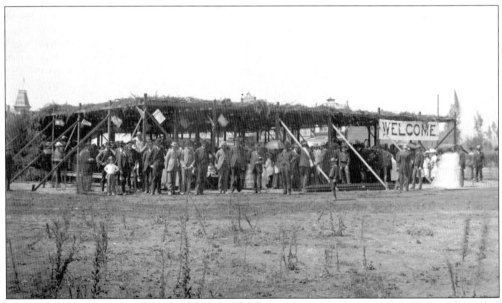

The opening of the railroad called for a big celebration on September 21, 1885. Townsfolk built a large pavilion near the tracks, covered it with freshly cut cypress boughs, attached a welcome sign, and waited for the first train to arrive. Five cars made the run from Los Angeles in 22 minutes.

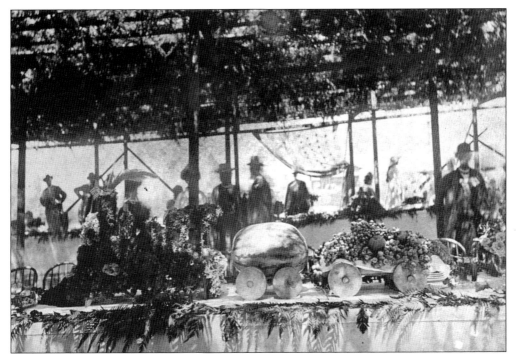

Inside the pavilion, tables covered with white tablecloths and decorated with flowers and ferns provided the setting for an abundant feast. The most elaborate table decoration was a locomotive and two cars constructed of flowers and laden with various fruits, including a large watermelon. This diminutive precursor of a Rose Parade float symbolized the bounty that the railroad would bring to the town.

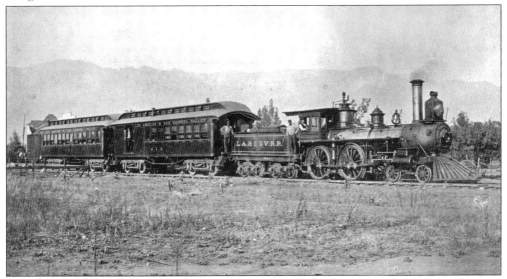

The first train brought five carloads of passengers, "including about 300 ladies," from Los Angeles to Pasadena in September 1885. The company continued laying track to the east and finally reached San Dimas or Mud Springs, as it was called, for a total of 28 miles of track. On January 1, 1887, the investors sold to the Santa Fe Railroad, which finally established a direct line from Pasadena to Chicago.

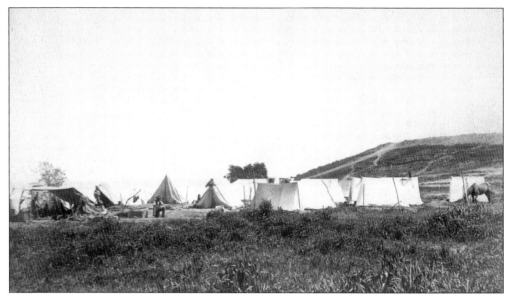

In 1883, Walter Raymond, a tour operator from Boston, purchased Bacon Hill, south of town, and hired architect J. H. Littlefield of San Francisco to design a fine hotel. Expecting to grade the hilltop in a few weeks, Raymond was disappointed to learn that it was bedrock and had to be blasted away at great expense. During construction, as many as 250 men lived in the camp pictured here. (Photograph by T. G. Norton.)

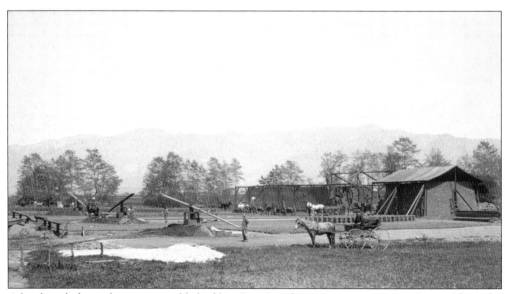

A brickyard, shown here, was established by a Los Angeles company just across the road from the Raymond site. Workmen manufactured over a million bricks for the foundation. The company, Gass, Simons, and Hubbard, also made bricks for the Carlton Hotel and the First National Bank building before their clay deposits in Pasadena gave out. (Photograph by T. G. Norton.)

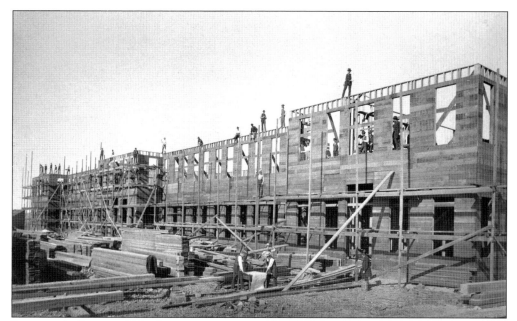

Framing the Raymond Hotel was an enormous task. Four stories with a tower 104 feet high, the Raymond on its hilltop could be seen for miles around. Built in the Second Empire style, associated with the reign of Napoleon III in France, and popular for public buildings in the United States in the 1860s and 1870s, the building featured distinctive mansard roofs. It was built entirely of wood. (Photograph by E. S. Frost and Son.)

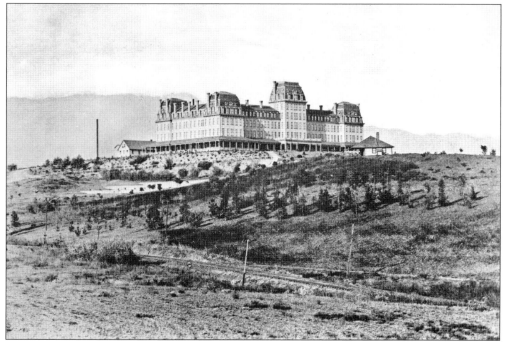

One of the largest buildings at the time in Southern California, the "Royal Raymond" opened in November 1886 with a celebration attended by 1,500 people. Although officially located in South Pasadena, it was always regarded as a Pasadena hotel. (Photograph by E. S. Frost and Son.)

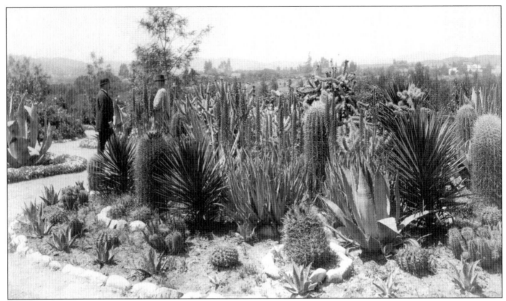

German landscape gardener Rudolph Ulrich laid out the grounds around the new Raymond hotel. Trained on great European estates, Ulrich designed the grounds of the Hotel del Monte in Monterey and several estates on the San Francisco Peninsula, including that of Leland Stanford. He planned the Raymond's spectacular desert garden in beds edged with local river rock. Ulrich went on to become landscape superintendent for the 1893 Columbian Exposition in Chicago. (Photograph by J. Hill.)

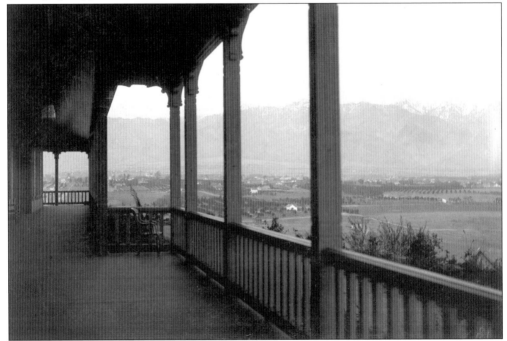

From the spacious veranda, guests at the Raymond could view the full range of the San Gabriel Mountains, snow-covered in this picture, and the agricultural landscape surrounding Pasadena. (Photograph by I. West Taber, San Francisco.)

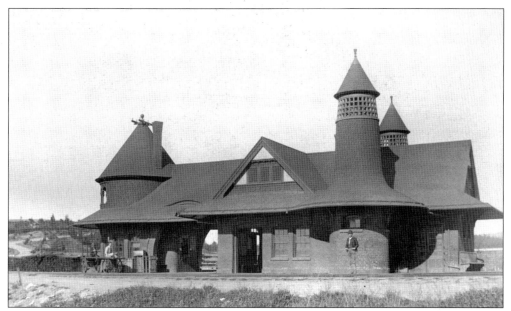

The Raymond had its own railroad station for the convenience of its guests. Built in the Richardsonian Romanesque style, inspired by the work of H. H. Richardson of Boston and designed by Ridgway and Stewart, the depot featured a broad arch leading to the platform, a large, round tower at one end, and two turrets projecting from the roof. It had a special waiting room for ladies, and open fireplaces for the rainy season.

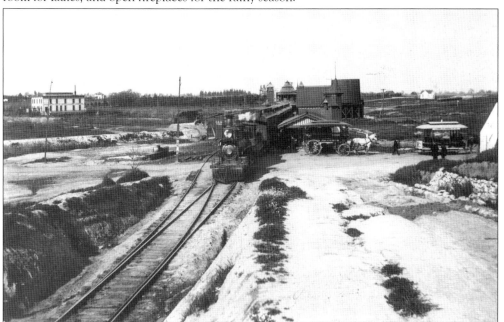

Guests disembarking from the train were met by carriages (seen on the right in this photograph) that brought them up the hill to the hotel. Two railroads served the station, the Atchison, Topeka & Santa Fe and the Terminal Road, a local line that ran from Altadena to Long Beach and Wilmington with connections to boats going to Catalina Island. The Terminal later became part of the Los Angeles & Salt Lake Railway (later the Union Pacific).

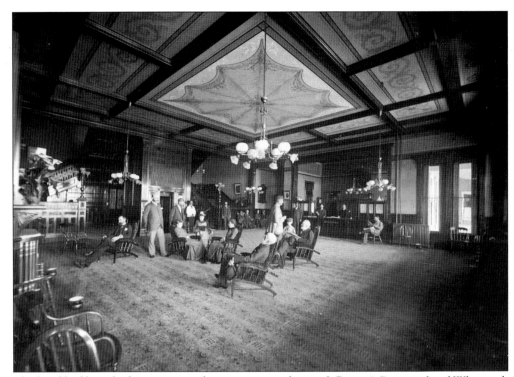

The hotel had been built to accommodate tourists traveling with Boston's Raymond and Whitcomb tours. Many of the guests came from Boston, arriving after days on the train to spend the cold months in sunny Southern California. Guests often celebrated Christmas in the East, arriving in Pasadena for New Year's Eve. Typically they would stay for several months, passing the time by socializing in the lobby and at meals, traveling through the countryside by carriage or on horseback, hiking to mountain camps above Pasadena, or taking the train to the ocean at Santa Monica or Long Beach. The hotel provided entertainment such as theatrical skits, parlor games, dancing, and concerts. When the hotel closed for the season in April, guests could look forward to spending the summer in the White Mountains of New Hampshire, where the Raymond's manager and staff operated a similar hotel. (Photograph by J. Hill.)

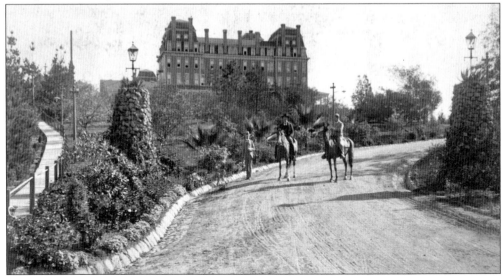

Three

AUCTION BOOSTS DOWNTOWN

The 1886 auction of five acres of schoolhouse land at the center of town had many consequences for the future growth and development of Pasadena. The freeing up of so much property along Colorado Street, from Fair Oaks Avenue east to the railroad tracks, encouraged rapid building eastward along the street, as well as development south along Raymond Avenue. Only a few months after the auction, Pasadena was incorporated as a city, and the old schoolhouse building, moved to the east side of South Raymond, became the new city hall, a much-needed municipal facility that was to relocate again at least twice in the downtown before the 1920s. The other public building on the schoolhouse property, Library Hall, was moved to Dayton Street while the new library building was under construction on North Raymond Avenue. The choice of the North Raymond location for the new library created a focal point for development northeast of downtown. The construction of the new schoolhouse on Marengo Avenue at Walnut Street brought substantial public investment further east and eventually determined the location of the civic center in the 1920s. All of these choices reinforced the general trend of eastward development of the business district.

The auction and the subsequent land boom occurring in the region encouraged investors to put substantial sums into buildings in Pasadena on East Colorado Street and Raymond and Fair Oaks Avenues. Brick buildings rapidly replaced wooden ones; the almost instant concentration of so many new buildings in the city was a dramatic change comparable only to the urban renewal projects of the late 20th century. Moreover, investors wanted the latest architectural styles, and Harry Ridgway and T. William Parkes, an English-trained architect who came to Pasadena around 1890, were happy to oblige.

The development of a streetcar system, initially consisting of horse-drawn, and later electrified trolleys, connected the downtown to Linda Vista, to Hill Avenue in the east, Washington Street to the north and within a few years, up into the mountains via the Mount Lowe Railway. This transit system, supplemented by train service to Los Angeles, provided a network for residents and tourists centered on downtown Pasadena.

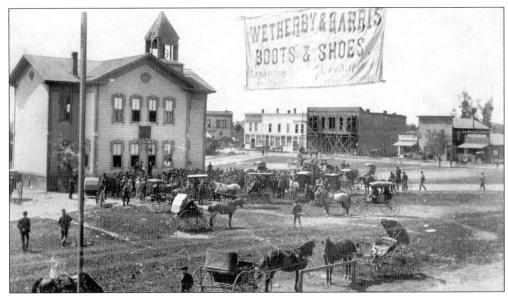

The schoolhouse auction on March 12, 1886, was a decisive event in the history of the downtown. Land speculation in Southern California was reaching a fever pitch, fueled by rivalry between the Southern Pacific and the Santa Fe. The sale of 35 lots from the school property brought in almost $45,000 and set off a building boom on the south side of Colorado Street and on South Raymond Avenue. (Photograph by Kohler.)

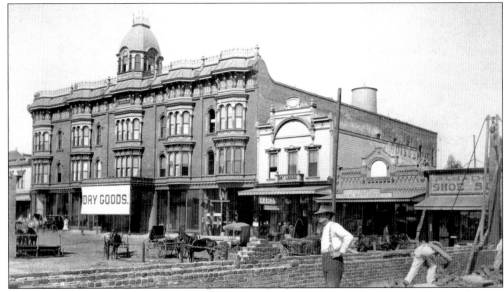

The vacant land on the south side of Colorado filled in so rapidly after the schoolhouse auction that an 1888 map shows the block between Fair Oaks Avenue and Raymond completely covered with new brick buildings. This photograph, with the Carlton Hotel in the background, shows masons at work on the brick walls of the new buildings. (Photograph by E. S. Frost and Son.)

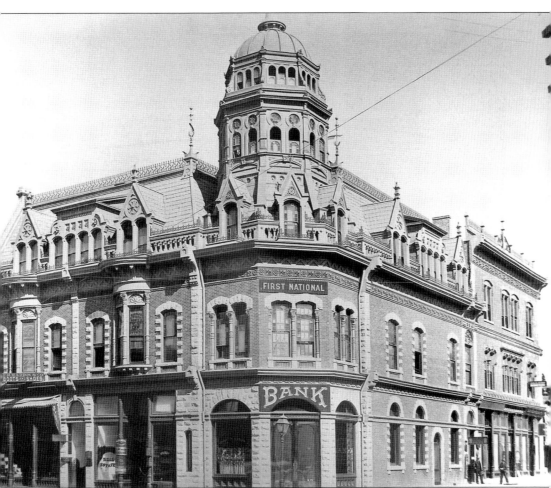

The transformation of The Corners began in 1886, when the magnificent First National Bank opened on the former site of the Los Angeles House hotel, at the northwest corner of Colorado Street and Fair Oaks Avenue. A three-story, brick building with a round two-story tower topped by a flagpole, the bank was the tallest building in downtown. Rough-dressed stone outlined doors and windows, and cast iron framed the shop fronts. The bank was designed by Harry Ridgway and was advertised as "thoroughly fireproof." It offered retail space on the Colorado frontage, with an entry to upstairs offices on Fair Oaks Avenue. Tenants on Colorado included the F. R. Harris shoe store and a real estate office. Upstairs offices were rented by lawyers, doctors, dentists, and by architect T. William Parkes. Another building by Ridgway, the Plant Block, also brick with stone trim in a Venetian Gothic style, is seen on the right in this photograph. As the principal architect working in Pasadena in the 1880s and 1890s, Ridgway prided himself on his ability to use and combine various styles, achieving what an earlier historian called "that ideal freedom from 'style' called the artlessness of art." The bank building, with its Romanesque arches, Italianate window hoods, Second Empire mansard roof, and Gothic dormers, is a stunning example of Ridgway's talent. (Photograph by Jarvis.)

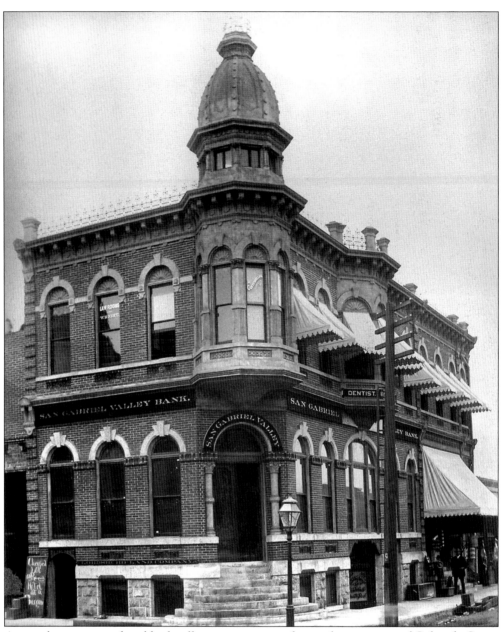

Across the street, on the old schoolhouse property at the southeast corner of Colorado Street and Fair Oaks Avenue, a rival bank (also designed by Ridgway) appeared within a few months. A more modest structure on a much smaller lot, the San Gabriel Valley Bank was also built of brick with stone arches over the windows and featured a corner tower. Only two stories tall plus a half-basement, it wrapped around the corner to include retail frontage on South Fair Oaks Avenue, where a barber and a butcher were tenants. The basement housed the Lordsburg Land Company. In the second story, at least one lawyer and a dentist had their offices, as well as Ridgway. (Photograph by Jarvis.)

Pasadena's first brick business building was only one story, erected in 1885 for Craig and Hubbard's grocery store at 37 East Colorado Street. Bricks came from L. J. Rose's ranch east of Santa Anita Avenue. A new two-story facade in the Spanish Colonial style, with false second story windows, replaced the original when Colorado Street was widened in 1929. The original one-story building, minus 14 feet, still remains behind the facade. (Photograph by E. S. Frost and Son.)

Located on Colorado Street, east of The Corners, the Carlton Hotel was a first-class establishment in the center of Pasadena's growing downtown. Known as the Exchange Block, and designed by Harry Ridgway, it opened in the summer of 1886. The Carlton boasted the first passenger elevator in town, and at its front entrance was the first benchmark from which all official city grades or levels were measured.

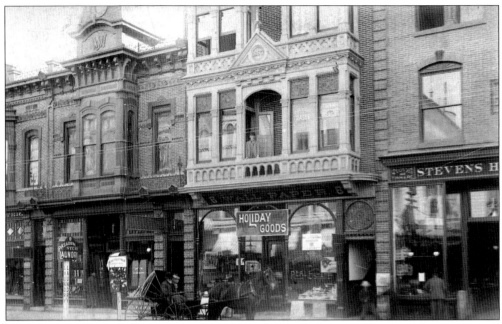

The many new business blocks built along the south side of Colorado Street on the schoolhouse land included the Wood and Banbury building of 1887 (the light-colored building in photograph). Designed by Ridgway and his new partner, Stewart, it was built of pressed brick, terra-cotta, Tehachapi stone, and galvanized iron in a style described as "Classic." Note the large plate windows on the first floor and the ornamental bay window on the upper floors.

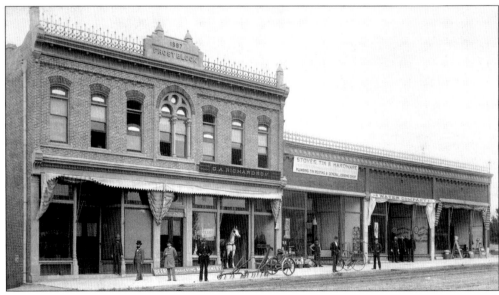

The second brick store in town, the Frost Block, was a single-story building finished in November 1885 on the north side of Colorado Street near Raymond Avenue. A second story was added in 1887. Owner Edward Sands Frost, a photographer, made many of the early images of Pasadena. In anticipation of the street widening, the facade was taken down in 1919, and a sober new front of white glazed brick replaced it, 14 feet back on the lot. (Photograph by Jarvis.)

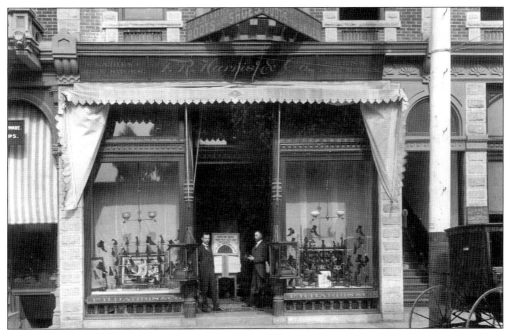

The Fred R. Harris shoe business occupied one of the Colorado Street storefronts in the new First National Bank building in 1886. Harris had married Hannah Ball, daughter of Benjamin F. Ball, and he continued to operate a prosperous business in Pasadena until the early years of the 20th century. (Photograph by J. Hill.)

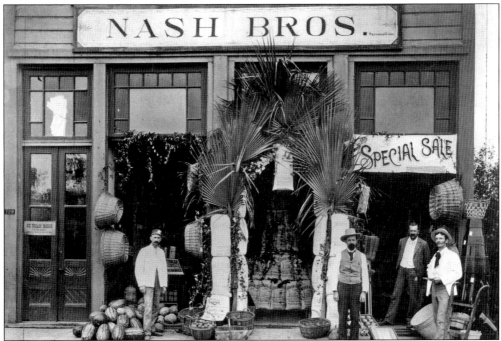

Nash Brothers started their grocery business in a small wooden building at 126 East Colorado Street. They prospered, and in 1899 they built a two-story brick building at the northwest corner of Colorado Street and Broadway (now Arroyo Parkway).

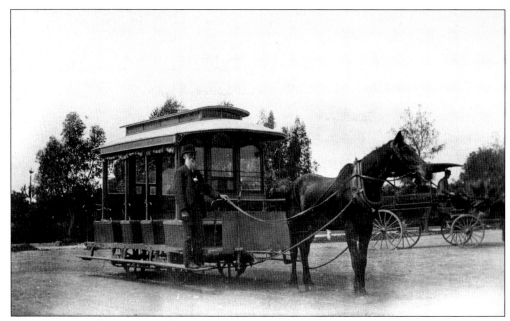

Horse-drawn trolleys came to Pasadena in 1885. By 1887, five streetcar companies had started building lines along major streets as far north as Washington Street and as far east as Hill Street. A streetcar even ran to Linda Vista Avenue over a new iron bridge on Holly Street. In 1894, the Pasadena & Los Angeles Electric Railroad bought out the horse-car companies, bringing the first electric car to Pasadena in 1895. (Courtesy California History Room, California State Library.)

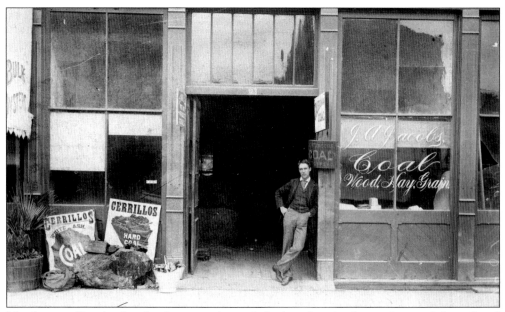

Merchants selling lumber, hardware, coal, wood, feed, and grain clustered around the railroad track. Many residents owned horses, kept a cow or two, as well as chickens. They cooked on wood stoves and used coal for heat. Jacob's Coal, Wood, Hay and Grain store, just east of the railroad on Colorado Street, sold all these items in a convenient location close to the center of downtown. (Photograph by Garden City Foto Company, Los Angeles.)

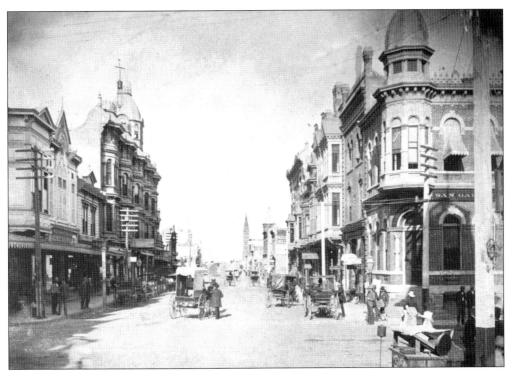

Just a few years after the first brick building appeared on Colorado, the street was lined with impressive brick business blocks. This view shows Pasadena's main business street looking east from Fair Oaks Avenue. The spire in the distance is the First Methodist Church, built in 1886 and destroyed in a windstorm in 1891. A second spire on the north side of the street belongs to the Presbyterian church. (Photograph by Lamson.)

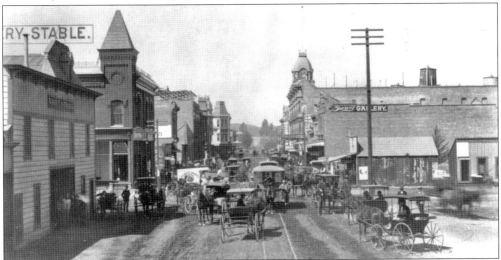

Looking west on Colorado in the late 1880s from Raymond Avenue, this view shows the Eldredge Block on the left (tower at the southwest corner of Raymond) and the Vore and Hoag livery stable on the far left. Beyond the Eldredge Block, brick buildings are under construction. The nearest brick building on the right is the Frost Block, and beyond it is the Carlton Hotel. Photographer Lucius Jarvis bought out Frost in the late 1880s.

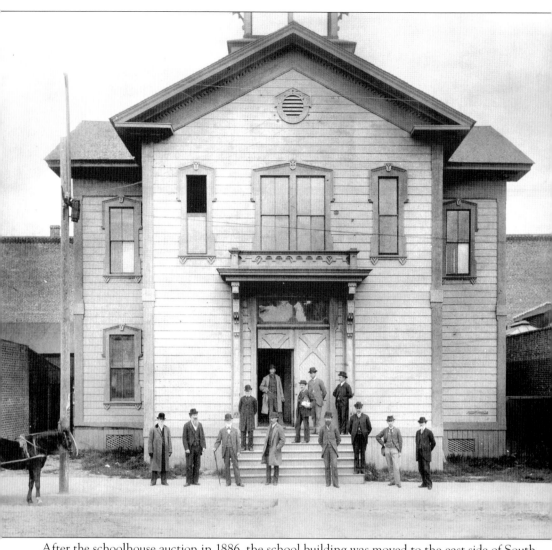

After the schoolhouse auction in 1886, the school building was moved to the east side of South Raymond Avenue, where it became Pasadena's first city hall, pictured here. As the city center grew eastward, Raymond Avenue became a prosperous commercial street. Library Hall, also on the school property, was moved to a small lot on Dayton Street, south of Colorado. (Photograph by C. F. Crandall; courtesy Special Collections, University of Southern California.)

Four

SOUTH RAYMOND AVENUE EXPANDS

The development of South Raymond Avenue after the schoolhouse auction received further impetus from E. C. Webster, who began construction of a hotel on South Raymond near the railroad tracks with money borrowed from Col. George G. Green. In 1891, Green took over the hotel, re-named it the Hotel Green, and expanded it over the next decade by adding five connecting buildings. Green's concept of surrounding his hotel with landscaped grounds led to the establishment of Central Park, south of the hotel, in 1902.

The park became a focus for the area, especially for tourists staying at the Green and other downtown hotels. For many years, it had a bandstand for concerts, and at various times, an aviary and even a small zoo found a home in the park. A bungalow at the north end of the park housed the Tourist Club, where tourists could meet to play cards or socialize. Later moved to the south end of the park, the bungalow is now the headquarters of El Centro de Acción Social, a social service organization. A roque court, a horseshoe pitch, and a lawn bowling green with clubhouse are surviving reminders of the tourist era in the park.

Banking on future development of the business center southward, Webster and other investors put up money to build the Grand Opera House on Raymond Avenue just south of the park in the late 1880s. It continued the Moorish architectural theme established by the Hotel Green, but was a financial failure. When Thaddeus Lowe took it over in 1891, he moved the offices for his business interests, including the Mount Lowe Railway, into the building and leased part of the space to a furniture store. The Opera House served as the location for community events, pageants, and the then-popular *tableaux vivants*, an art form that recreated famous paintings using sets and live actors onstage, similar to the well-known Pageant of the Masters still playing in Laguna Beach. The area around the park, hemmed in by railway lines to the east and west, developed into an industrial zone, coexisting with and eventually displacing residents of Pasadena's minority communities.

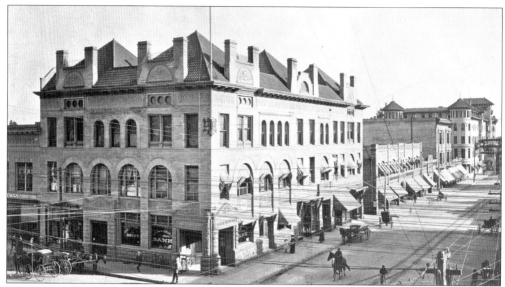

Several handsome brick buildings soon replaced the wooden schoolhouse on the east side of South Raymond Avenue. This view shows the Masonic Temple Block at the corner. To its right is the small, but elegant Vandervort Building by Los Angeles architect Frank Hudson, constructed with an unusual golden brick. The Vandervort Building is still standing. South of Kansas Street (now Green Street) is the Hotel Green. (Photograph by J. Hill; courtesy Special Collections, University of Southern California.)

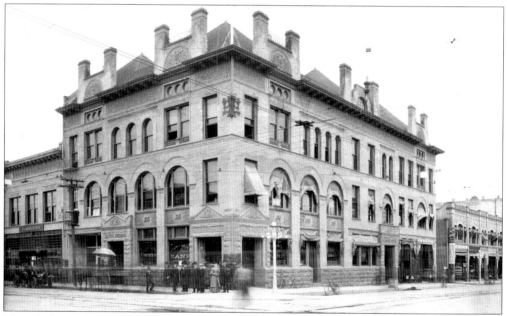

Harry Ridgway designed the imposing Masonic Temple block at the southeast corner of Raymond and Colorado in a Romanesque Revival style in 1894. Its robust form contrasted with Ridgway's earlier First National Bank building of 1885–1886. In response to the 1929 street widening, the building was drastically altered. The only recognizable features today are the arched windows in the second story. The third story was removed completely. (Photograph by C. C. Pierce; courtesy Special Collections, University of Southern California.)

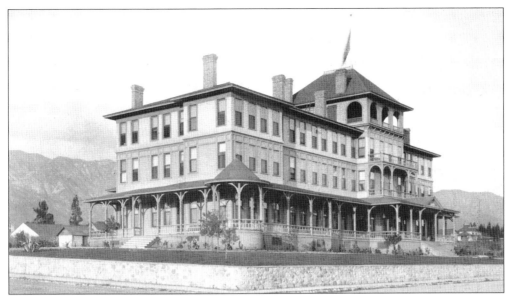

Raymond Avenue was becoming Pasadena's "hotel avenue." Instead of stopping at the Green or the Raymond, travelers could take a carriage from the station north on Raymond to the Painter Hotel, opened in 1888, up on Washington Street. Designed by architect Nathan Philbrick for John H. Painter, a Quaker from Iowa, the Painter was the third largest hotel in Pasadena, and at 1,200 feet above sea level, was popular with health-seekers. (Photograph by Henderson.)

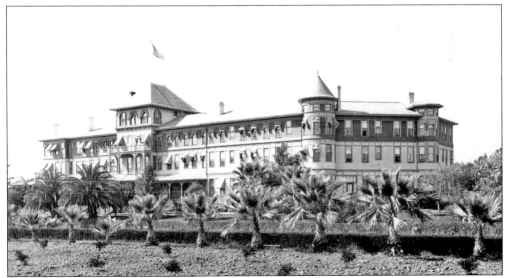

Also known as La Pintoresca, the Painter prospered initially. A large wing added on the east side featured a distinctive corner turret. Built of wood, like the Raymond Hotel, the Painter suffered a devastating fire on New Year's Eve in 1912 and was never rebuilt. The site became a public park, designed by prominent landscape architect Ralph Cornell, and later the location of a branch library.

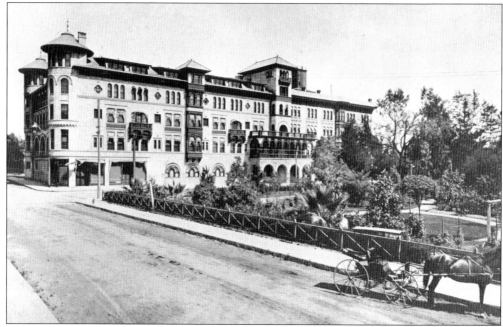

Pasadena's second major downtown hotel, after the Carlton, was the Hotel Green, built in 1891–1893. Col. G. G. Green, who had made his fortune in patent medicine, was the principal investor. The finished building was 300 feet long and extended over 90 feet from Raymond Avenue to the railroad line in the rear. At five stories, it was the tallest building in the downtown at the time.

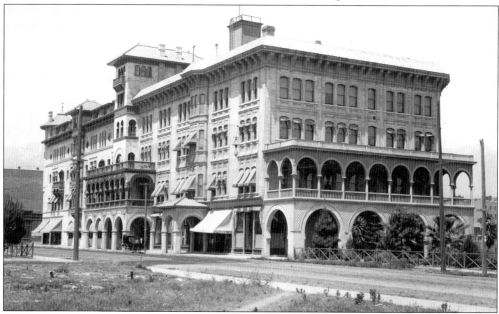

An earlier, smaller hotel, the Webster, built in 1886, was incorporated into the Hotel Green building. Its owner, E. C. Webster, had the foresight to build a train depot behind his hotel in 1887, and the railroad agreed to occupy it, giving the hotel the best location in Pasadena to capture tourists. This view from the south shows the older portion, the original Webster Hotel, with Colonel Green's addition to the north. (Photograph by G. L. Rose.)

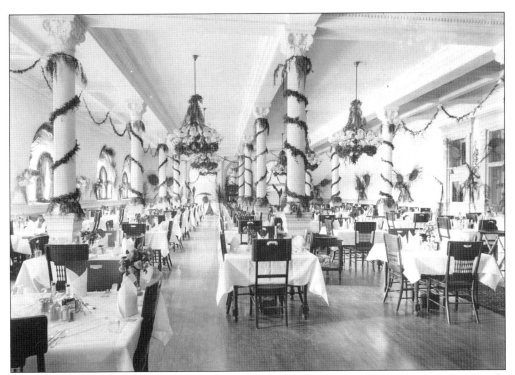

The Hotel Green dining room is decorated for Christmas Eve in 1896. Almost completely demolished in the 1930s, the hotel building remains as a one-story remnant on the corner of Green Street and Raymond Avenue.

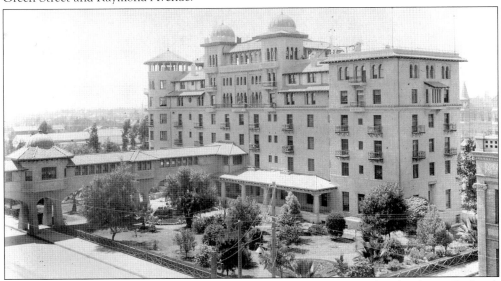

Not satisfied with doubling the size of the original hotel, Colonel Green hired architect Frederick Louis Roehrig (1857–1948) to design an annex on the west side of Raymond Avenue, connected to the older building by a bridge over the street. Roehrig provided an even more romantic Moorish design than the original, complete with multiple round towers and a gilded frieze reminiscent of designs by Chicago architect Louis Sullivan. (Photograph by William H. Fletcher; courtesy California History Room, California State Library.)

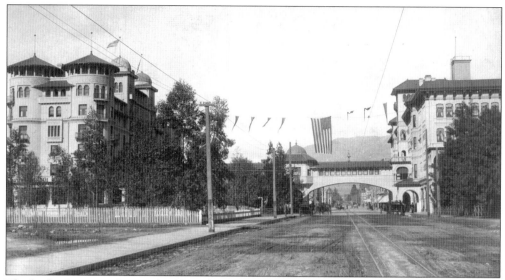

The bridge between the two buildings led to the annex that was set in park-like grounds, well back from the street. Although the portion over the street has been demolished, the bridge still spans the space between the street and the annex. Now known as the Castle Green, the annex retains many interior and exterior details. (Photograph by Lowry Brothers.)

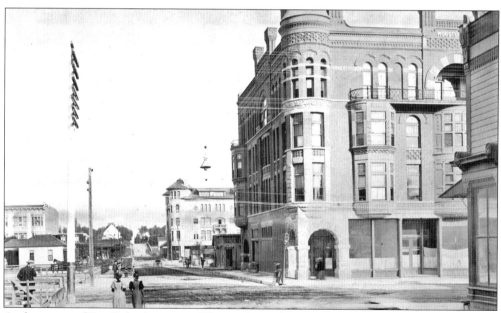

At the corner of Fair Oaks Avenue and Kansas Street (now Green Street), Philander G. Wooster of Boston built the Wooster Block, designed by Charles L. Strange, in 1888. In 1903, Colonel Green incorporated the Wooster into his hotel complex by adding a west wing along Green Street. The Wooster Block was briefly the first home of Throop University, now Caltech. (Photograph by William H. Fletcher; courtesy California History Room, California State Library.)

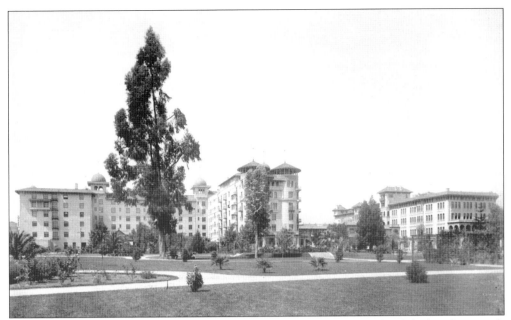

The Hotel Green complex covered almost two city blocks. The 1902 sale of the hotel's grounds south of Dayton Street to the city financed construction of the wing connecting to the Wooster Block. This photograph shows, from left to right, the Wooster Block, the 1903 connecting wing, the Castle Green, the Raymond Avenue bridge, and the first Hotel Green on the far right. In the foreground is Central Park. (Photograph by C. C. Pierce; courtesy Special Collections, University of Southern California.)

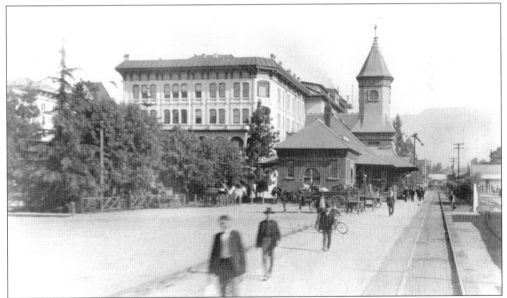

A Romanesque-style brick building with an imposing tower, the Santa Fe station was the arrival point for most travelers to Pasadena. The Hotel Green was adjacent to the station, and the Hotel Green annex can be glimpsed through the trees on the left. The small square brick building with the large arched doorway near the center of the photograph was the baggage room; it is all that remains of the old station.

Pasadena's first park, Central Park, was established in 1902. Noted landscape architects, including the Olmsted Brothers of Boston and Jens Jensen of Chicago were invited to submit designs, but in the end a local nurseryman, Thomas Chisholm, got the job. This view of the park shows the pond, the bandstand, and the Hotel Green beyond. (Courtesy Ninde Collection; Pasadena Museum of History.)

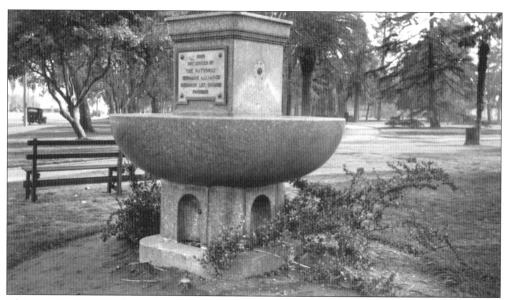

This granite drinking fountain, with a large bowl for horses and small basins at the bottom for dogs, stood in the middle of Dayton Street, just south of the Hotel Green. The National Humane Alliance donated it to Pasadena in 1905. The fountain was moved to the northeast corner of Central Park, where it still stands today.

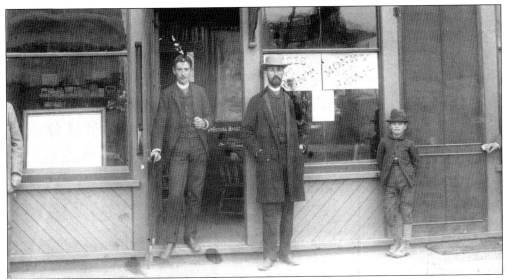

The Hotel Green brought customers to South Raymond Avenue, and what better place to offer real estate to the tourists? William R. Staats, who came to Pasadena from Connecticut when he was 19 for his health, founded one of Pasadena's most successful real estate firms. The first office of Leggett and Staats was located at 12 South Raymond Avenue in 1888. (Photograph by Forrester and Orr, Los Angeles, Chicago.)

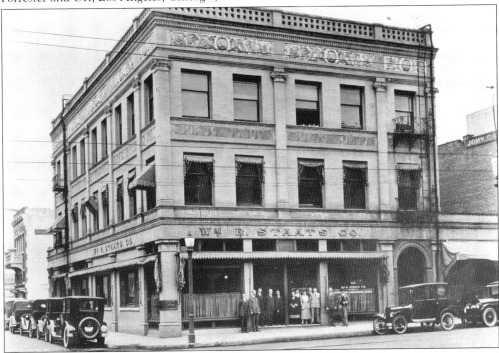

By 1900, the Staats Company was housed in the Macomber Block at the northwest corner of Green and Raymond Avenue, across the street from the Hotel Green. Staats had weathered the crash of the 1880s real estate boom and soon became an investor in banking, title insurance, and real estate. He is remembered in Pasadena as the developer of the Oak Knoll section, the first neighborhood in town to be laid out with curving streets.

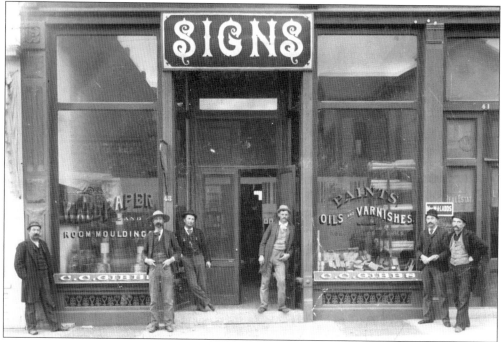

In the mid-1890s, Charles C. Gibbs at 43 South Raymond Avenue offered paints and wallpaper, oils, varnishes, and room moulding. Gibbs ran a painting and decorating business. His shop also advertised sign and carriage painting. (Photograph by William Henry Hill; courtesy California History Room, California State Library.)

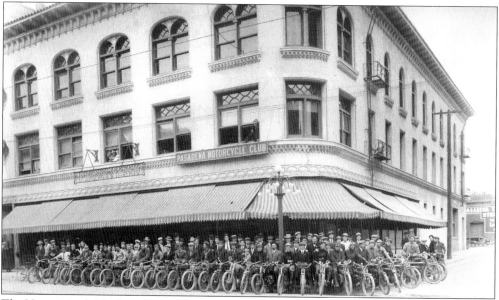

The Victor Marsh Block at the northeast corner of Raymond Avenue and Green Street boasted a curved facade and elegant windows, now drastically altered. Designed by architect John Parkinson of Los Angeles in 1902, the building housed Marsh's shop of fine antique Japanese wares. This c. 1920 photograph shows members of the Pasadena Motorcycle Club in front of the building. (Photograph by George Daskam.)

Five

NORTH RAYMOND

The development of the area northeast of the town center was encouraged by the public library building (1886–1890) and the adjoining Library Park, Pasadena's second park. Although close to the railroad tracks, the neighborhood did attract residential buildings, some of them substantial, along Walnut Street, Raymond Avenue, Summit, and Chestnut Street. The large Universalist Church building (1886) on Chestnut, and the Shakespeare Club (1896) on nearby Fair Oaks Avenue, along with the opening of the first campus of Throop Polytechnic Institute (later Caltech) in 1892, created a strong institutional focus in the neighborhood.

The 1890s and early 1900s also saw many commercial buildings appearing along North Raymond Avenue and the adjacent blocks of Union Street. The Auditorium Building at Raymond and Union (architect, Seymour Locke, 1896) became the headquarters of the YMCA for a few years. The Union Bank Building (Charles Buchanan, 1901) and the Kinney-Kendall Block (Greene and Greene, 1896) provided lodge meeting halls for the Elks and the Odd Fellows, respectively, as well as considerable modern office space for the growing downtown. Construction of twin eight-story buildings on North Raymond in 1913, the Stevenson Building and the Central Building, one a standard office building, the other a loft building that initially housed the Pasadena Furniture Company, broke with Pasadena's earlier architectural traditions, both in scale and style. Both buildings exhibited large tripartite Chicago windows and stark lines, bringing a modern presence to the street. North Raymond, a street that had earlier been given over to livery stables, blacksmith shops, and lumberyards, grew into a busy center of retail shops, banks, lodge halls, and offices by the 1920s.

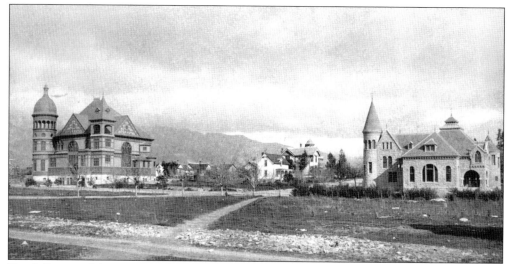

North Raymond Avenue at Walnut Street was way out in the country in 1890. The Universalist Church on the left in this photograph went up in 1888–1889. The free public library (on the right) opened in 1890 at the corner of Walnut and Raymond. The houses on Walnut in the center of the photograph belonged to Thomas D. Allin and John Allin, both prominent in Pasadena civic and business affairs. (Photograph by Lamson.)

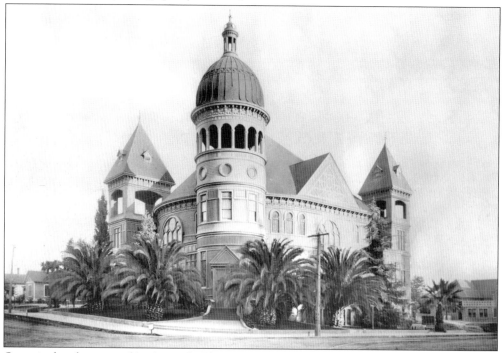

Organized and supported by Amos G. Throop from Chicago, the Universalist Church building, designed by Strange and Gottschalk, was completed in 1889. The large structure at the corner of Raymond Avenue and Chestnut Street was financed almost completely by "Father Throop, " who donated $40,000 toward it. Its Romanesque-style architecture was carried out in wood, instead of the usual stone or brick. (Photograph by C. C. Pierce; courtesy Special Collections, University of Southern California.)

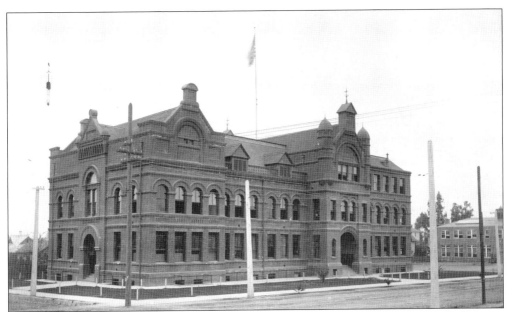

Amos Throop founded Throop University in 1891, originally housed in the Wooster Block at Fair Oaks Avenue and Green Street. A year later, the name of the college was changed to Throop Polytechnic Institute with the motto, "learn to do by doing." In 1893, East Hall, designed by Harry Ridgway, opened on the new campus between Fair Oaks Avenue and Raymond Avenue at Chestnut Street, just across from the Universalist Church. (Photograph by C. McMurtrey.)

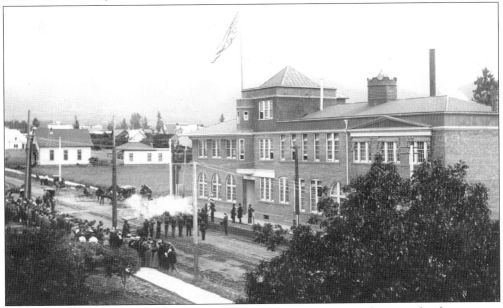

Throop's West Hall, designed by T. William Parkes, opened in 1892, housing the departments of mechanics and physics. Machinery and equipment for woodworking, ironwork, electric work, cooking, and sewing were installed, as well as laboratories for chemistry and biology. There was even a designated classroom for a new skill—typewriting. Throop admitted both male and female students. Literary and fine arts classes, as well as administrative offices, were in East Hall, the main building on campus.

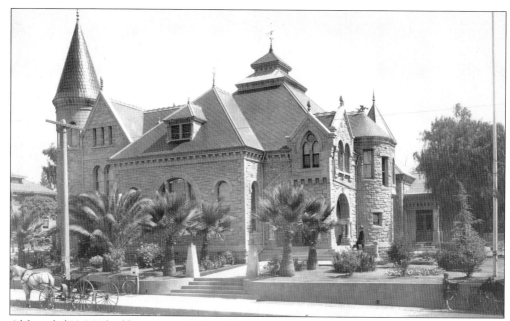

Although $10,000 had been set aside for a library from the schoolhouse auction funds, the grand stone Romanesque-style building designed by Harry Ridgway would cost much more. Work began in 1886 at the corner of Raymond Avenue and Walnut Street, but the stone contractor failed, leaving the walls unfinished and the library short of funds. The new building, costing over $40,000, finally opened in September 1890.

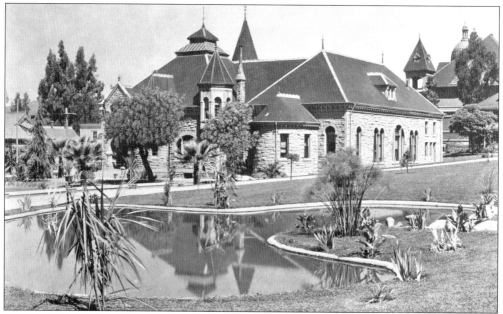

With its romantic stone towers, complicated rooflines, and tall gables, the library was one of the most magnificent buildings in town. The square tower at the top of the building had a skylight below, bringing light into the second floor reference room. A beautiful pond behind the library building was an important feature of the landscaping of Library Park, established by the city in 1906.

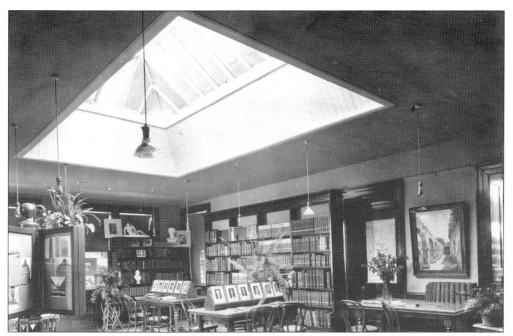

This interior view of the library's reference room shows the light well above. Prints and photographs of classical sculpture and architecture and of a California mission are displayed on the walls and tables, fostering interest in art. Note the electric lights hanging from the ceiling. Pasadena's electrification began in 1886.

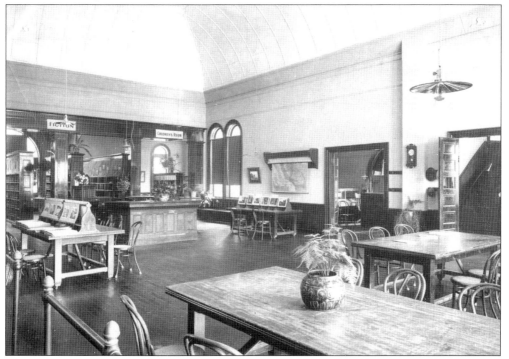

This view of the library reading room shows a deeply coved ceiling and arched windows. A sign to the right of the main desk reads, "Children's Room." Plants and art prints decorate the room.

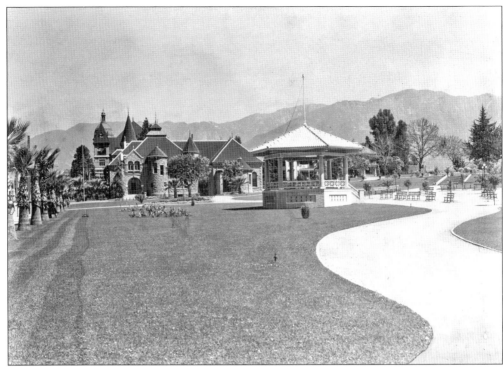

Palms were set out to line the entrance walk to the library and along Raymond Avenue. This view from about 1908 shows the bandstand, a curving walk, and the young palms along Raymond. A residential neighborhood grew up near the new library, with substantial houses lining Raymond, Walnut, and Chestnut.

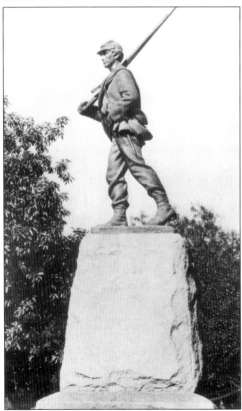

Pasadena's oldest war memorial, this bronze monument to the "Volunteer of '61" was erected in Library Park in 1906. The statue's sculptor, Theo Ruggles Kitson, one of the most noted of her time, sculpted many war memorials around the country. The park became the place for other memorials including one to mothers and fathers of Union veterans, prompting its renaming as Memorial Park. (Courtesy Pasadena Public Library.)

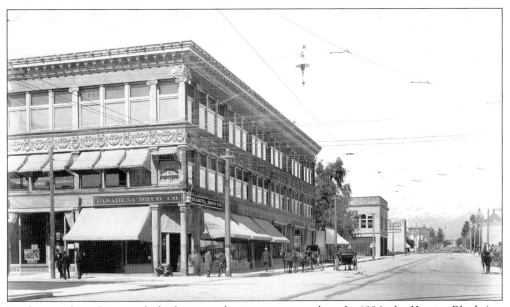

Farther south on Raymond, the business district was expanding. In 1896, the Kinney Block (on the left), designed by Greene and Greene, went up on the northwest corner of Colorado Street. The architects used new Chicago-style windows, continuous bands of windows grouped in threes, to bring maximum light into the upper-story office space. Elegant classical details clothed the modern, iron-frame structure. (Photograph by William H. Fletcher; courtesy California History Room, California State Library.)

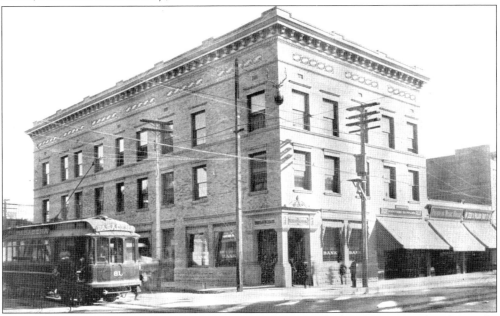

Union Bank built its new building across from the Kinney Block in 1901. Its sober design, by architect Charles W. Buchanan (1852–1921), also stipulated an iron frame, but the narrow windows and thick, brick walls exude solidity. The local Elks lodge met upstairs, as evidenced by the elk head mounted on the corner of the building in this photograph. The building received a new art deco facade in 1929.

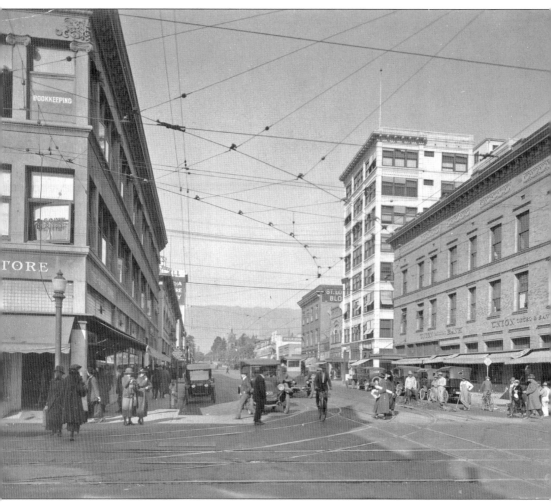

By 1920, new business buildings had gone up along North Raymond Avenue. Union Bank is on the right, and behind it is the eight-story Central Building. The latter, built in 1913, was one of a pair of nearly identical buildings on the street, the other being the Pasadena Furniture Company building at 91–93 North Raymond. The facade of the Kinney Block on the left has already been remodeled and simplified. (Photograph by Hiller and Mott; courtesy Special Collections, University of Southern California.)

Six

RENEWAL OF
THE CORNERS

By the turn of the century, the old, frame buildings on Colorado Street at Fair Oaks Avenue were looking quite out of date. Moreover, the corner locations, with their exposures in two directions, were well-situated for multistory office buildings, like those built in the 1890s at the Colorado and Raymond intersection. In the first decade of the new century, two large new buildings, the Dodworth Block and the Slavin Building, replaced the Ward Block and the Williams Block, the original buildings of The Corners. These new office buildings would be followed by the Chamber of Commerce Building further east on Colorado at Broadway in 1906, by the Citizen's Bank Building at Marengo in 1906–1912, and by the Central Building on Raymond in 1913, bringing more modern office space to the downtown.

A new generation of architects began to put their stamp on Pasadena's downtown. Frederick Louis Roehrig (1857–1948) had come to Pasadena in the late 1880s, following his father, a newly appointed professor of Oriental languages at the fledgling University of Southern California. Trained as an architect at Cornell, where his father had taught, Roehrig had already designed many of the grand mansions in Pasadena and Los Angeles by 1900, as well as several business blocks, the Hotel Green Annex (now the Castle Green), and numerous smaller houses. Throughout his career, Roehrig displayed remarkable facility as a designer, working in many styles, but always producing harmonious results.

Other important new buildings on North Fair Oaks Avenue included the new city hall and jail at Union Street; a new Masonic temple; a vaudeville theater, the Savoy, where the Community Playhouse (later the Pasadena Playhouse) gave its first performances; and several churches, including the Catholic church, St. Andrew's.

West of North Fair Oaks, near the railroad tracks, was a minority neighborhood, where churches, such as the African Methodist Episcopal Church (later Scott Methodist) were located. The Japanese Union Church, located in a frame building on North Fair Oaks, later moved to Mary Street, west of Fair Oaks. Unfortunately, no photographs of these pre-1920 churches west of Fair Oaks survive. Another black neighborhood flourished near the tracks west of South Fair Oaks, where Friendship Baptist Church was originally located on Vernon Avenue. These minority neighborhoods were mostly eliminated by urban renewal and the construction of the 210 Freeway in the 1970s.

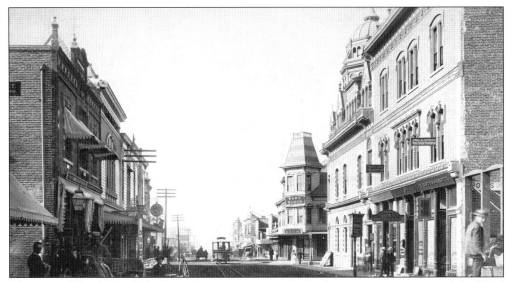

This view of North Fair Oaks shows the intersection with the distinctive square tower of the Ward Block, as it looked in about 1894. Construction at the far right is for the Mary Bartlett building that would house the Model Grocery. (Photograph by Jarvis.)

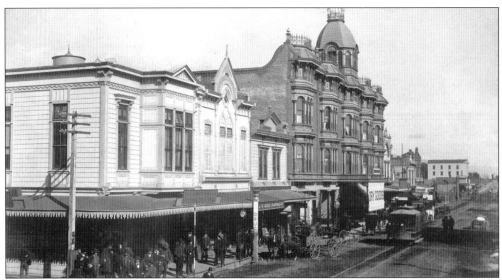

A photograph from the 1880s shows the old northwest corner of Colorado Street and Fair Oaks Avenue with Pasadena's first business building, the Barney Williams store, and the two adjacent wooden buildings that were not replaced until 1905. (Photograph by Jarvis.)

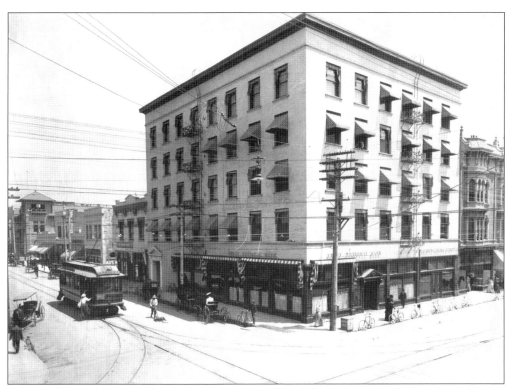

Successful local builder and contractor, Matthew Slavin, hired architect Frederick Roehrig in 1904 to design a new six-story brick building for the northwest corner of Fair Oaks Avenue and Colorado Street. Roehrig came up with a simple utilitarian design, its only ornaments consisting of a small cornice running around the top of the building and a classical pediment to mark the entrance on Fair Oaks Avenue to the offices upstairs.

In 1901, Alden R. Dodworth, who had made money in the Pennsylvania oil fields, hired architect Joseph J. Blick (1867–1947) to design this building of white, pressed brick to replace the old Ward Block. The interior of the five-story building was finished in quarter-sawn oak, boasted 42 office spaces, and had an electric elevator. The building still stands, although it was altered in 1930 to accommodate the widening of Colorado Street. (Courtesy Security Pacific Collection, Los Angeles Public Library.)

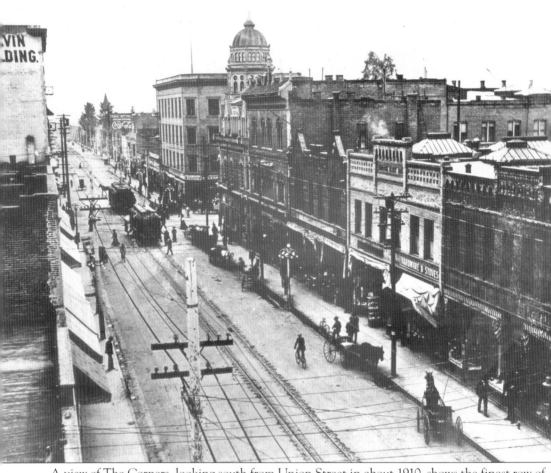

A view of The Corners, looking south from Union Street in about 1910, shows the finest row of Victorian buildings still standing in Pasadena. At the far right is the Martha Block of 1899, left of that the Slavin Block of 1893; beyond that is the Mary Bartlett Building of 1894, and beyond that the three-story Plant Building of 1887. Only the Bartlett facade, originally the work of Harry Ridgway, has been altered. (Courtesy Seaver Center, Los Angeles Museum of Natural History.)

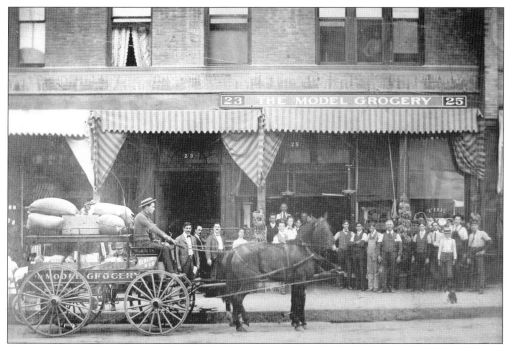

Founded in 1894, the Model Grocery was an institution in Pasadena until well into the 1950s. The first store was at 23–25 North Fair Oaks Avenue in the Mary Bartlett building. The Model prospered by offering high-quality products and outstanding service. The store printed an elaborate catalogue, encouraging customers to phone in their orders for delivery. This 1902 photograph shows the staff and a delivery wagon in front the store.

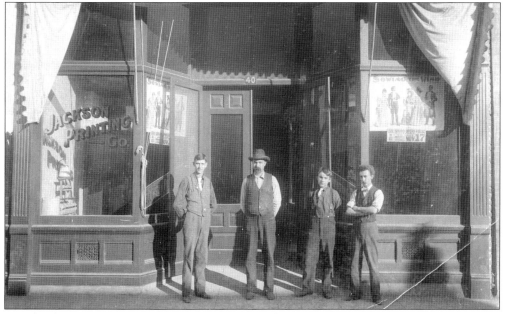

Another business on North Fair Oaks Avenue in the 1890s was Jackson Printing Company at 40 North Fair Oaks Avenue. As retail trade increased on the street, such establishments moved onto side streets, such as West Union, where rents were cheaper.

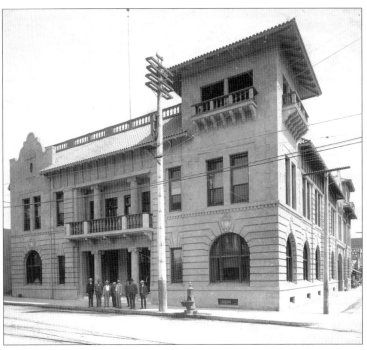

The new city hall and jail, opened in 1903 at the northeast corner of Fair Oaks Avenue and Union, was a handsome Mission Revival–style building designed by Los Angeles architect Carroll H. Brown. The city rejected Irving Gill's design, submitted with his partner Will Hebbard. Note the cast-iron drinking fountain with a basin for horses at the curb in front of the building. (Photograph by C. J. Crandall; courtesy Special Collections, University of Southern California.)

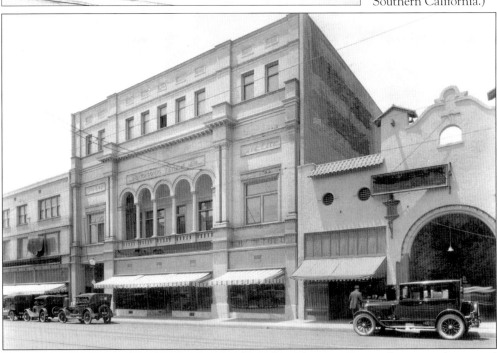

The Renaissance Revival–style Masonic temple, with its distinctive open loggia on the second story, went up in 1905 at 93 North Fair Oaks Avenue. The Masons moved out in the 1920s, but the building, designed by Henry F. Starbuck of Long Beach, remained until its demolition in the late 1970s for an urban renewal project, despite its eligibility for listing on the National Register of Historic Places. At right in the photograph is the Savoy theater, the first home of the Pasadena Playhouse. (Courtesy Pasadena Public Library.)

In 1899, Pasadena's Catholics built a new brick church, St. Andrew's, at the northeast corner of Fair Oaks Avenue and Walnut Street, in the same block as the Throop Institute campus. The handsome brick building, similar to other churches built at the time in the diocese, served the parish until the late 1920s, when the present St. Andrew's Church went up at the corner of Raymond Avenue and Chestnut Street.

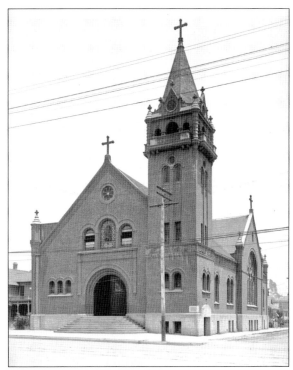

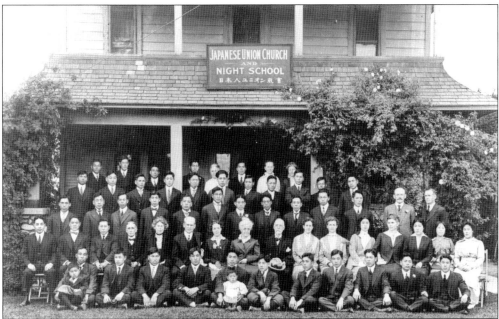

The Japanese Union Church originally met in the First Congregational Church at South Marengo Avenue and Green Street. That group combined with another Japanese mission organized by First Friends Church to form the Japanese Union Church at 215 North Fair Oaks Avenue, pictured here in 1916. In the 1920s, the congregation built a new church on Kensington Place that has since been destroyed by the 210 Freeway. (Courtesy Shades of L.A. Archives, Los Angeles Public Library.)

A prominent building on North Fair Oaks Avenue at Lincoln Avenue was the Shakespeare Club's home, a replica of Anne Hathaway's cottage in Stratford-upon-Avon in England. Built in 1896 to plans by Charles W. Buchanan, the clubhouse served the women's literary society, founded in the 1880s, until that organization moved to a new building on South Los Robles Avenue. In 1914, the old club building was donated by Miss Susan Stickney to the Music and Art Association for a school of fine arts. It became the home of the Stickney School of Art, which counted prominent local artists such as Guy Rose and Jean Mannheim as faculty members. Pasadena's Beaux Arts Society, an organization of architects teaching the Beaux Arts method, also held classes at the school. In 1934, the building was sold to raise funds for the Pasadena Art Institute, the first art museum in Pasadena. (Photograph by C. C. Pierce; courtesy University of Southern California.)

Seven

EASTWARD EXPANSION
BEFORE 1900

The intersection of Marengo Avenue and Colorado Street became a focal point in the expansion of Pasadena's downtown. Led by the Methodist Church, built at Marengo and Colorado in 1886, followed almost immediately by the Presbyterians, who built one block further east, and Wilson School, which went up facing Marengo two blocks north of Colorado, the eastward expansion of downtown commercial buildings along Colorado continued through the 1880s and 1890s.

As early as 1888, a brick building, the Brockway Block with offices and stores, opened at the Marengo intersection across from the Methodist Church. Other churches, including All Saints' Episcopal and a congregation of German Methodists, built new buildings in the neighborhood east of Marengo.

During the 1890s, many new residents chose to build mansions along East Colorado Street. Among them were Mr. and Mrs. James Swan, who hired the young brothers, Charles and Henry Greene, to design their house, Torrington Place, an eclectic mix of Shingle style and Colonial Revival elements located east of Los Robles Avenue. The Vandervort brothers, John and Robert, built their houses in the same block, hiring architect T. William Parkes, member of the Royal Institute of British Architects. Like the churches, these showplaces would fall victim to commercial development in the early years of the 20th century.

In the 1890s, two disasters hit Pasadena. The first was the great windstorm of December 1891, which almost destroyed the Methodist church and damaged the Presbyterians' tower. Several houses were destroyed and businesses damaged. The second disaster, a fire that destroyed the Raymond Hotel in April 1895, certainly affected Pasadena's tourist trade, but proved advantageous for the many hotels, large and small, that continued to build and expand in Pasadena. It took six years before the new Raymond opened.

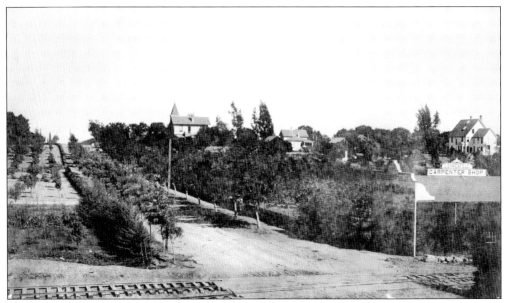

Blocked on the west by Orange Grove Avenue and the Arroyo Seco, Pasadena's downtown could expand only eastward. Charles Ehrenfeld's shop, built in 1883, was the only business building on Colorado Street east of the tracks in this 1885 photograph. Scattered residences were appearing on the Marengo ridge. (Photograph by Martin Behrmann.)

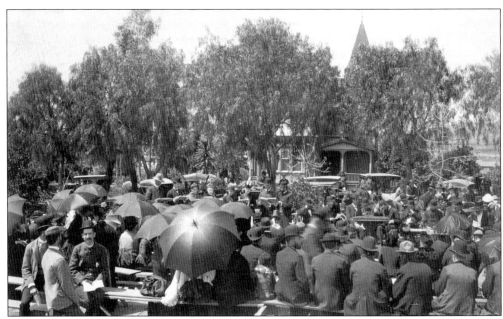

Methodists gathered at the corner of Colorado Street and Marengo Avenue on April 16, 1886, to lay the cornerstone of their new church. The congregation had its beginnings in 1875, meeting in the small Presbyterian church on California Street. The following year, the Methodists built their own church on Orange Grove Avenue at Palmetto. The building was moved to Colorado Street in 1883. By March 1886, enough money had been raised to start work on the foundation of the new church. (Photograph by E. S. Frost and Son.)

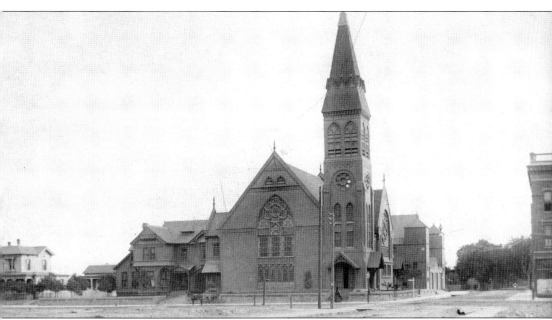

Dedicated on March 20, 1887, the new First Methodist Church boasted a 140-foot steeple that became a favorite lookout point for photographers. The Gothic-style, wooden church and its adjacent parsonage contained an auditorium, Sunday school classrooms, a lecture room, kitchen, and church parlors, all designed by Ridgway and Ripley. Clinton B. Ripley had come to Pasadena from Maine in 1876, but his partner Harry Ridgway, arriving from Canada in 1878, was the first to open an architect's office in Pasadena. These two formed a partnership and, in 1884, opened a planing mill. The firm designed and built two schools, a business building, and several residences before dissolving sometime in 1886. Ripley carried on the mill business, which became the Pasadena Manufacturing Company, doing over $100,000 worth of business in 1886. He later became a prominent architect in Hawaii. The Methodist Tabernacle, built in 1888 behind the church, seated 2,000 and was the biggest hall in Pasadena, hosting an oration by Susan B. Anthony in 1895. This photograph, from about 1890, shows a brick commercial building, the Brockway Block, on the west corner of Marengo Avenue, across from the church. Designed by Ridgway in a "Venetian" style with arched windows, it opened in the spring of 1888. The business district was clearly moving east along Colorado Street.

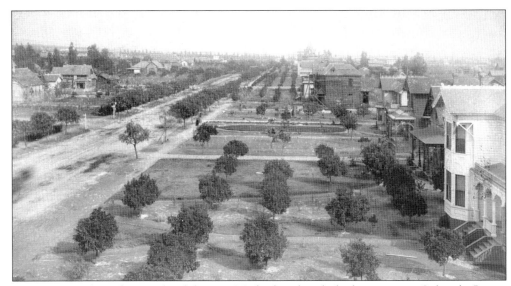

An 1886 view from the steeple of the new Methodist church, looking east on Colorado Street, shows a residential neighborhood, with remnants of orange groves in the front yards of the houses and a new house going up. The small, white Presbyterian church, partially visible on the far left, had been moved from its original location on California Street in 1885 to Colorado Street, and Worcester Avenue (now Garfield). (Photograph by E. A. Bonine, Lamanda Park.)

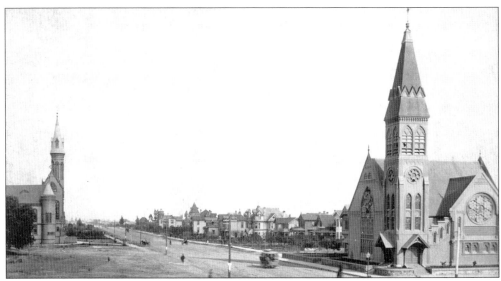

The Presbyterians replaced their small chapel with a large new church in 1886. The two churches, Presbyterian on the left and Methodist on the right, were pioneers in developing this part of Colorado Street. The Presbyterians would move east again in 1904, the Methodists not until the mid-1920s.

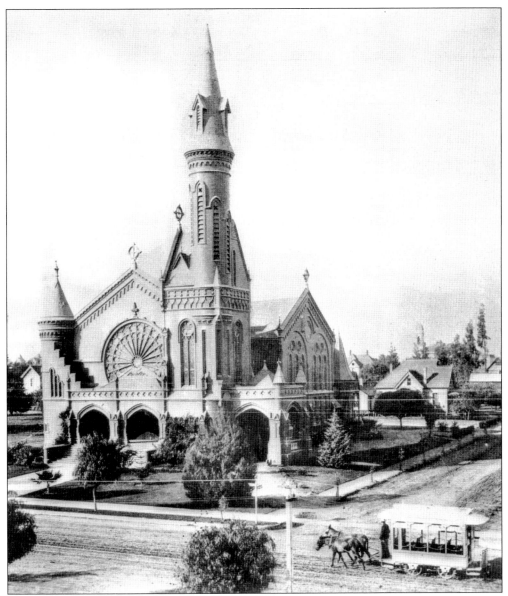

The new Presbyterian church, a Romanesque-style brick building with an unusually tall spire, housed the first large pipe organ in town. The Presbyterians, the oldest congregation in Pasadena, were split by the decision to move to Colorado Street. The dissidents built another church, the First Congregational Church, on California Street, which later became Neighborhood Church. This photograph, looking northwest at the corner of Colorado Street and Worcester (now Garfield Avenue), also shows the tower of Wilson School in the background on the right. (Photograph by C. C. Pierce; courtesy Special Collections, University of Southern California.)

This view north from the Methodist church in 1886 shows the framing for the new Wilson School in the middle ground behind the houses on the right. The community named the new school, built with funds from the schoolhouse auction, after the original land donor, Benjamin Wilson. Nine architects submitted plans, including Ridgway, but J. M. Stewart of San Diego got the job. (Photograph by E. S. Frost and Son.)

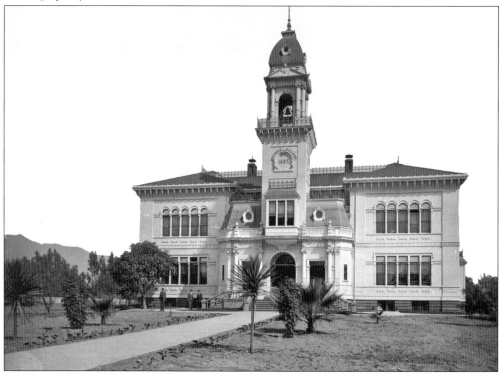

The new Wilson School was an elegant building in the Italianate style; the tall tower with its bell dominated the neighborhood. Located on Marengo Avenue at Walnut Street, the building was set well back on the lot facing Marengo in the area now occupied by Pasadena's civic center.

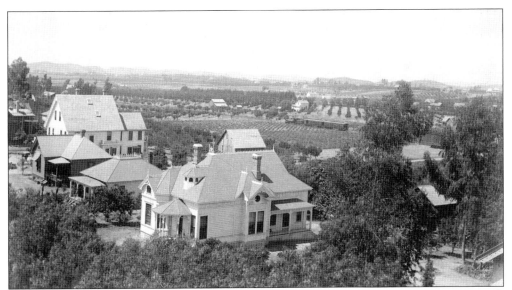

This c. 1886 view from the Methodist church steeple shows substantial houses lining South Marengo Avenue in the foreground. In the background, the landscape is agricultural with groves of trees and vineyards. A train is visible just to the left of the tallest tree on the right side of the photograph. (Photograph by E. S. Frost and Son.)

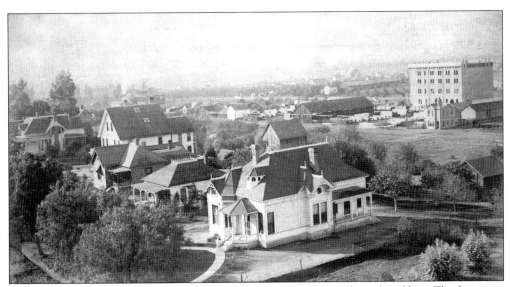

A later view from the same point shows many new buildings along the railroad line. The four-story building on the right is the Webster Hotel, which became the Hotel Green after it was taken over and expanded by Col. George G. Green in the early 1890s.

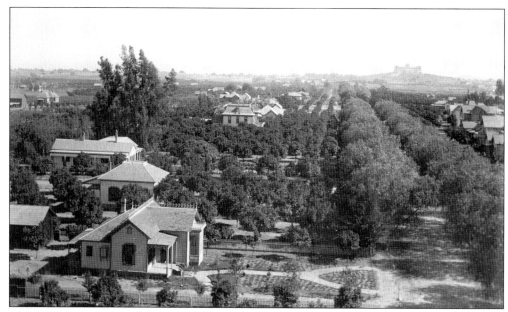

This late-1880s view south from the Methodist church along Marengo Avenue shows the double row of pepper trees for which the street was famous. In the background is the Raymond Hotel on its high hill. The west side of the street was favored because of better views, so the houses are larger there. Many groves still remain in the front yards. (Photograph by E. S. Frost and Son.)

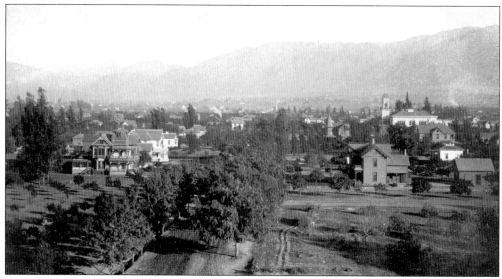

The new Wilson School dominates this view from the Methodist church north on Marengo Avenue. Probably taken in the 1890s, the image shows many more houses than in the photograph on page 66, especially to the northwest on the land west of Marengo. (Photograph by Jarvis.)

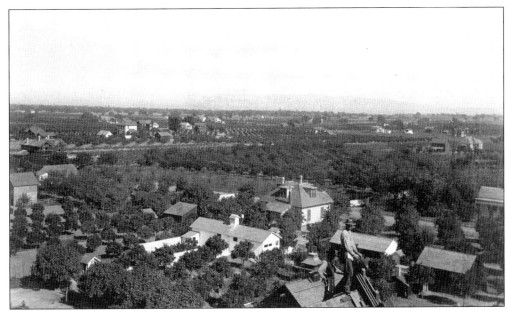

A view to the southeast from the Methodist church in about 1886 shows an agricultural landscape with scattered houses. In the right foreground, two workmen, probably roofers, perch at the ridge of one of the church's gable roofs. (Photograph by E. S. Frost and Son.)

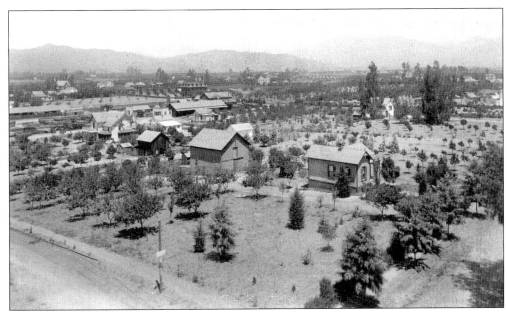

A view to the northwest from the Methodist church in about 1886 shows the railroad line and various buildings associated with a lumberyard on the left in the middle ground, scattered houses amid groves, and the Linda Vista hills in the background. Colorado Street runs diagonally across the bottom left of the photograph. (Photograph by E. S. Frost and Son.)

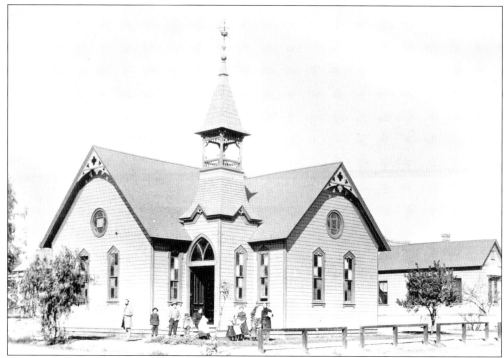

Built at the corner of Ramona Street and Worcester (now Garfield) Avenue in 1887 in a Carpenter Gothic style, the German Methodist Episcopal Church was located just east of the new Wilson School. Organized in 1882 by German-speaking residents, the church had 65 members in 1895.

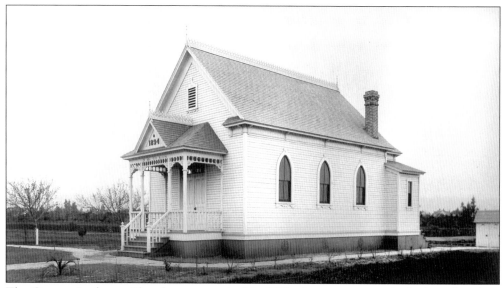

The German Lutheran Church was organized in 1893; the congregation built their church at the corner of Vernon and Walnut Street in 1894, on the north edge of the downtown business district. (Photograph by Kohler.)

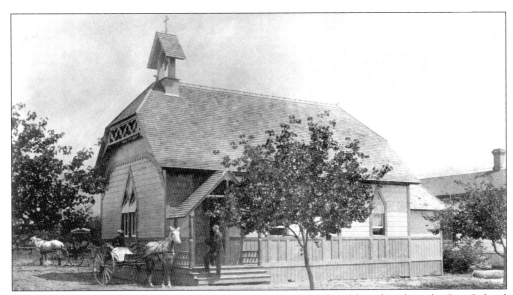

All Saints Episcopal Church began in 1884 as a mission from the oldest church in the San Gabriel Valley, the Church of Our Saviour in San Gabriel. In 1885, Ridgway and Ripley designed a chapel for the mission on East Colorado Street near Euclid Avenue, pictured here.

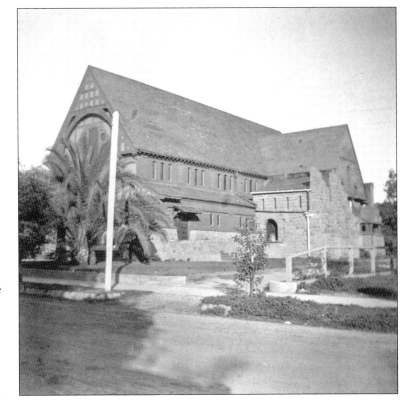

Just three years later, All Saints built a handsome stone church on North Euclid Avenue, designed in the Gothic style by San Francisco architect Ernest A. Coxhead. This church served the parish until the 1920s when a new church replaced it.

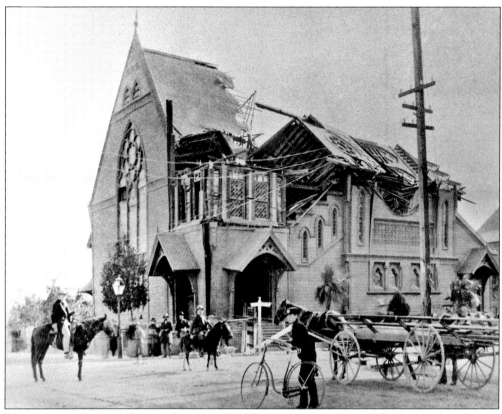

The great windstorm of December 11, 1891, blew down the tower of the Methodist church, crushing the roof. The storm destroyed two other churches, blew the tin roof off the Raymond Hotel's tower and tore tin roofs off several downtown buildings. Several houses were blown down or heavily damaged, but nobody was injured seriously.

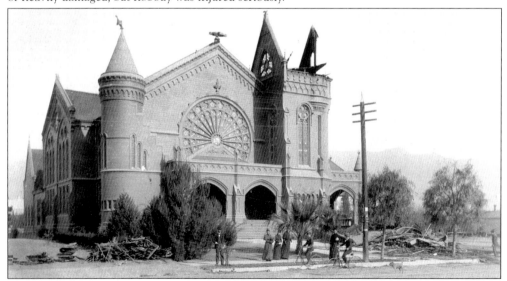

The windstorm blew over the Presbyterian Church steeple but otherwise did little structural damage to the brick building. (Photograph by C. J. Crandall.)

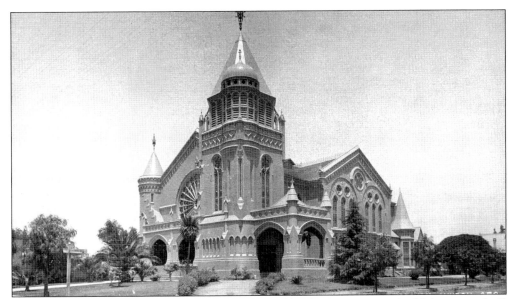

The Presbyterians repaired their tower relatively quickly, choosing not to rebuild the original tall slender spire. (Photograph by C. J. McMurtrey.)

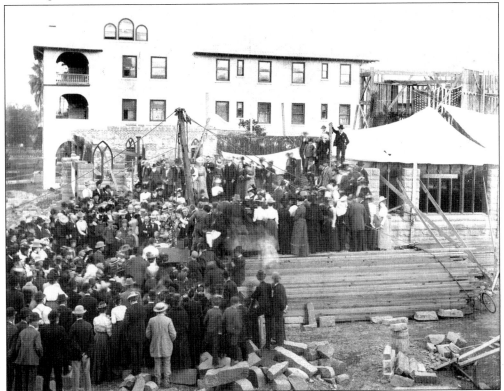

The Methodists, although they repaired the building and made do, soon embarked on a new building program, laying a cornerstone for their new church on the same site. The lower stone walls of the new church, designed by Los Angeles architect John C. Austin, are already in place in this photograph. (Photograph by J. Hill.)

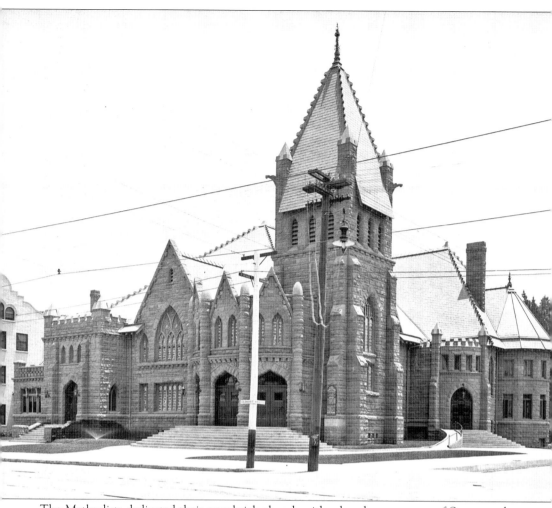

The Methodists dedicated their new brick church with a handsome veneer of Sespe sandstone in 1901. Designed by Los Angeles architect John C. Austin in a Norman Gothic style, the church had a slate roof, and an interior of oak and Oregon pine. In the 1920s, the building was dismantled and reassembled at Holliston and Colorado, where it was became the Holliston Avenue Methodist Church.

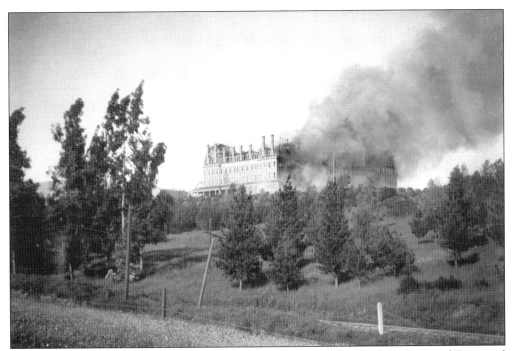

Another disaster struck on Easter Sunday afternoon, April 14, 1895, when the Royal Raymond burned to the ground in less than an hour. Most of the guests were not in the building at the time of the fire. Fortunately, no lives were lost, and there were no serious injuries.

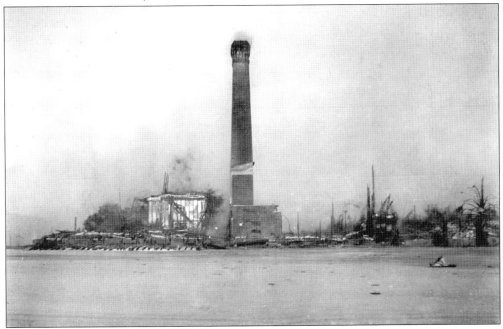

All that was left of the enormous wooden building were the remains of a few chimneys and a pile of debris. Guests, who had lost their belongings, were moved to other hotels, such as the Green, the Painter, and Echo Mountain House on Mount Lowe. The loss was not fully covered by insurance, so it took Walter Raymond several years to raise the cash to rebuild.

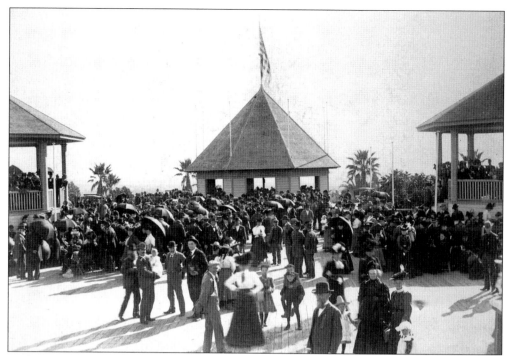

In the meantime, Walter Raymond built a pavilion over the brick foundation of the former hotel. Here tourists could enjoy the famous views and attend the dances put on by Raymond, where there was always plenty of food and drink. (Photograph by Jarvis.)

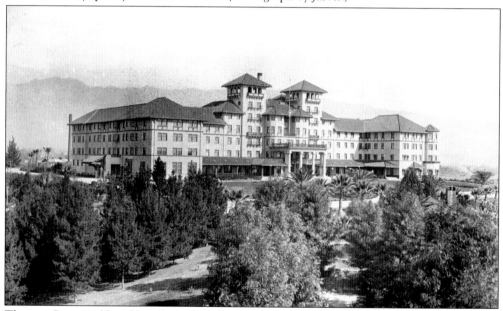

The new Raymond hotel rose from the ashes in 1901, thanks to the investment of $300,000 by plumbing magnate Richard T. Crane of Chicago. Designed by Los Angeles architects Hunt and Eager, the new hotel in the Mission style was resolutely fireproof. Guests arriving on the electric car at the Fair Oaks trolley stop could reach the lobby by elevator from a tunnel dug through the hill. (Courtesy Special Collections, University of Southern California.)

Eight

DOWNTOWN SERVES GROWING CITY

As the downtown grew, it kept pushing outward, forcing smaller businesses to relocate from Colorado Street, and Fair Oaks and Raymond Avenues. They moved to such streets as Kansas (now Green), Union, DeLacy, and Dayton, or to Vernon and Mary, which have been obliterated by urban renewal and freeway construction. West Colorado Street, because of its proximity to the freight lines of the Los Angeles & Salt Lake Railway (later Union Pacific), attracted industrial uses, especially auto garages and car dealerships. Lumberyards and other construction-related businesses also located near the tracks, initially along the Santa Fe line, but later along the Union Pacific line.

Pasadena's first public parks, Central Park, south of the Hotel Green, and Library Park, surrounding the public library on North Raymond Avenue, enhanced their neighborhoods south and north of the downtown, making them more attractive to residents and tourists. Investors also speculated on current fads and how the town would grow, building an opera house south of Central Park, and a cycleway from the park to the Raymond Hotel to capitalize on the bicycle craze of the 1890s. However, their dreams of a cycleway all the way to Los Angeles were not realized.

Minority communities were forced to live in neighborhoods close to downtown and close to the railroad tracks. The Asian community, initially the Chinese, later joined by the Japanese, had been banished to land south of California Street and east of Fair Oaks Avenue. Mexican immigrants concentrated in the same neighborhoods, living in small houses on Broadway, Raymond, and Fair Oaks and on the cross streets south of the park. African Americans also lived near the railroad. Their major churches were west of Fair Oaks, both north and south of Colorado. Some Japanese also lived around Mary Street and Kensington Place, where their church was located. These minority neighborhoods were especially subjected to pressure by expanding manufacturing and service businesses: auto shops, laundries, warehouses, the municipal electric plant, a gas works, and Pasadena Hospital (later Huntington Hospital) all brought noise and pollution to these residential neighborhoods. Discriminated against by protective covenants, the minority residents had very few options to move to other neighborhoods in Pasadena, even if they could afford to.

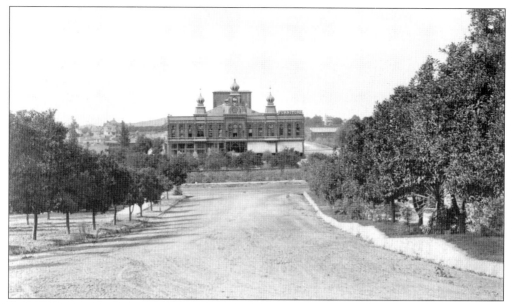

E. C. Webster and others with land interests south of Central Park built the Grand Opera House on South Raymond Avenue at Bellevue Street in 1888–1889 for $100,000. Designed to rival the Alcazar of San Francisco, it seated 1,500. Although Madame Modjeska sang here, the investors went bankrupt. In 1891, Thaddeus Lowe of Mount Lowe Railway fame took over the building. It stood until the late 1920s. (Courtesy California History Room, California State Library.)

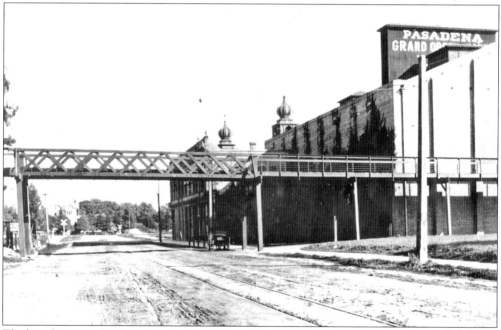

The bicycling craze hit Pasadena in the 1890s, and in 1897 Horace Dobbins formed the California Cycleway Company to build an elevated road from Pasadena to Los Angeles. The first leg of the cycleway, running between Raymond and Fair Oaks Avenues from the Hotel Green to Raymond Hill, opened on New Year's Day 1900. This photograph shows the cycleway crossing Bellevue Street behind the Grand Opera House.

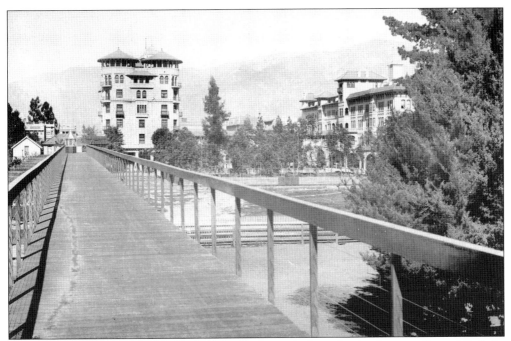

The cycleway started at the Hotel Green, running south through what became Central Park. In the small kiosk was a ticket taker, but the cycleway never paid for itself, so it never reached Los Angeles as originally planned. (Photograph by Putnam.)

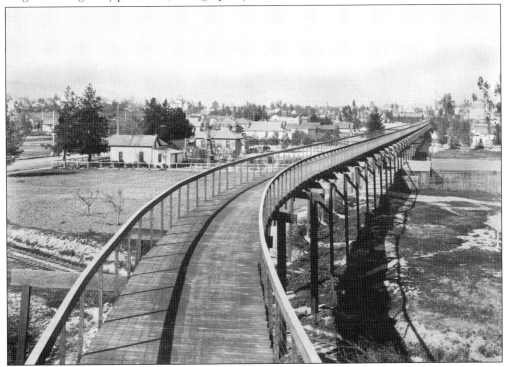

Just north of the Raymond Hotel, this view looking northwest shows Fair Oaks Avenue on the left. The cycleway spans the railroad track in the foreground. (Photograph by Putnam.)

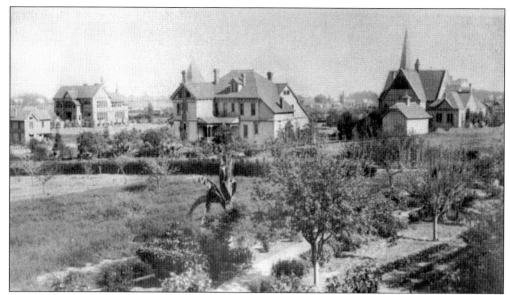

The Garfield School (on left), built in 1888, and the First Congregational Church (on right), dedicated in 1891, were considered to be on the outskirts of town on California Street at Pasadena Avenue.

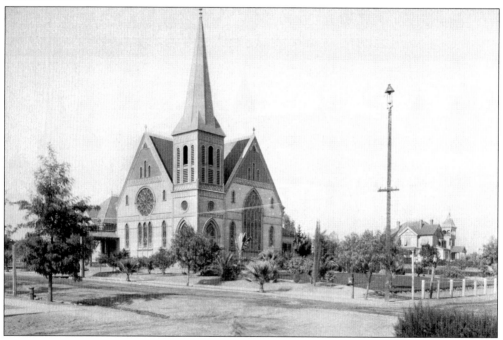

Many members of the early Presbyterian congregation, formerly Congregationalists, had considered founding their own Congregational church even before the Presbyterians moved from California Street to build a new church on Colorado Street in 1886. Shortly afterwards, in 1892, the First Congregational Church was renamed Neighborhood Church and later affiliated with the Unitarians. Designed in a Gothic Shingle style, the building stood until 1974, when it was demolished overnight by the State of California, an event that became a major catalyst for the preservation movement in Pasadena. (Photograph by J. Hill.)

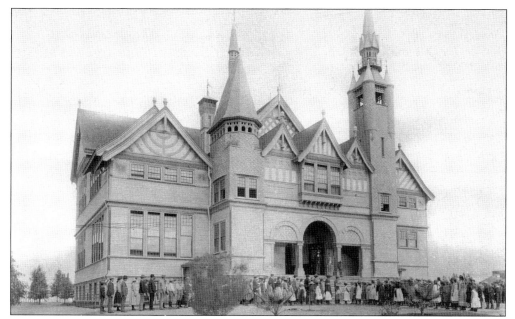

Garfield School was designed by Ridgway, Stewart, and Son in 1888 in what was called at the time the "Anglo-Teutonic" style. Built near the railroad tracks and the California–Fair Oaks neighborhood, which was settled by Asians following their removal from the town center in the 1880s, the school drew many of its pupils from Mexican and Asian immigrant families. (Photograph by J. B. Blanchard.)

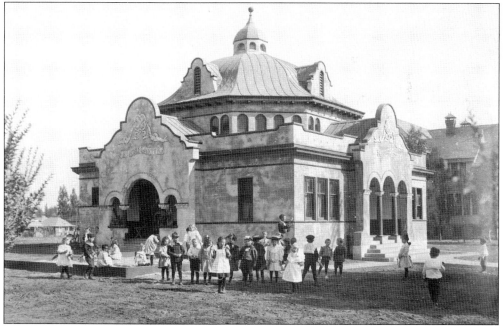

In 1901, Pasadena public schools began offering kindergarten classes. This charming kindergarten building in the Mission Revival style behind Garfield School was designed by Henry Starbuck of Long Beach, winning out over plans submitted by Pasadena architects Charles W. Buchanan, W. B. Edwards and Carroll H. Brown of Los Angeles. (Photograph by Lovick.)

Manual training was an important part of the curriculum in many schools around 1900. This photograph shows Garfield children in a *sloyd*, or woodworking class, an education program borrowed from Sweden to teach manual dexterity and the use of tools. Throop Polytechnic Institute also emphasized manual training in its early years. (Photograph by Lovick.)

Our Lady of Guadalupe Church was built in about 1911 as a mission emanating from St. Andrew's Catholic Church. Primarily it served Mexican immigrants who lived south of Central Park near the railroad tracks in Pasadena's industrial district. The modest shingled chapel burned down in the 1980s, and its faithful parishioners were absorbed into St. Andrew's congregation.

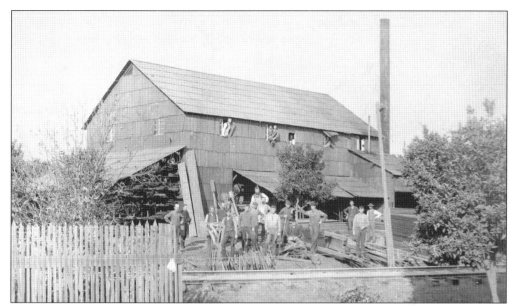

Industrial buildings concentrated along the railroad tracks or on the back streets, such as Union and Green Streets. J. G. Simpson's shake mill, located at Chestnut and the Santa Fe tracks was one of many earlier businesses based on the construction industry, one of Pasadena's major employer from the 1880s until well into the 20th century.

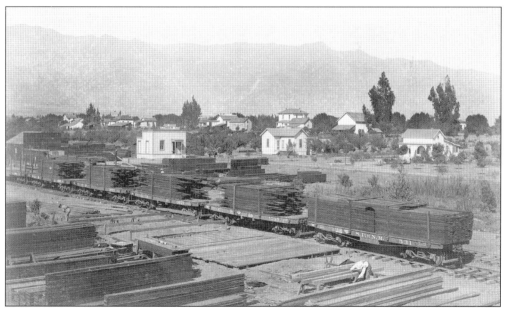

This view of the railroad tracks looking northeast from Colorado Street shows railroad cars stacked with lumber. Behind the cars, the small flat-roofed office of the San Pedro Lumber Company stands at the corner of Union Street and Broadway (now Arroyo Parkway). (Photograph by E. S. Frost and Son.)

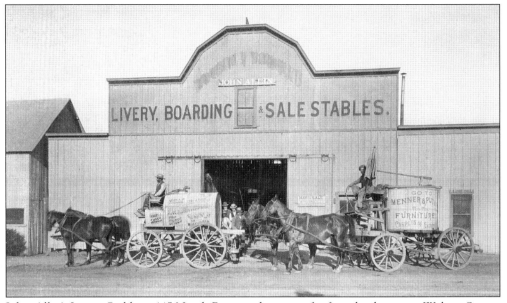

John Allin's Livery Stable at 145 North Raymond was not far from his home on Walnut Street, east of Raymond Avenue.

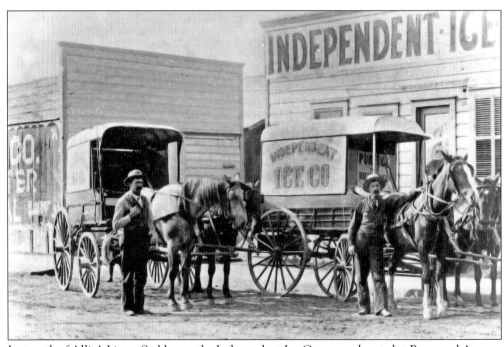

Just south of Allin's Livery Stable was the Independent Ice Company, located at Raymond Avenue and Union Street in about 1895. Owned by J. C. Rust (left) and S. L. Rust (right), the company shipped natural ice from Truckee, stored it in sawdust and delivered it in large blocks to the iceboxes of residential and commercial customers. (Courtesy Pasadena Public Library.)

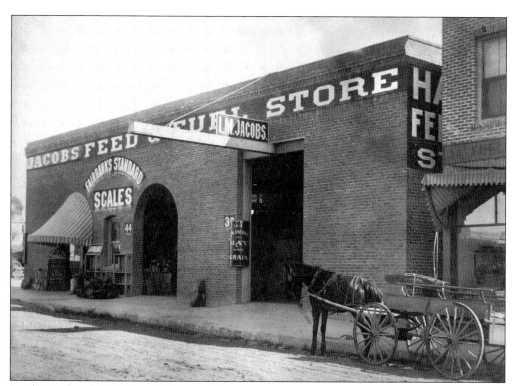

Jacobs Feed and Fuel, located in a wooden building on East Colorado Street in the 1890s, had moved to a brick building at the corner of Union and Broadway (Arroyo Parkway) by 1909. The profit from the sale of his valuable property on Colorado allowed Jacobs to build a better building on Union Street.

Blacksmiths were essential in the horse and buggy era. Besides shoeing horses and fashioning gates and fences, Stevenson and Burkett Blacksmiths also repaired carriage tires. Blacksmith shops were concentrated on West Union Street in the 1890s. This shop was probably located in one of the alleys off Union or Green Streets. By 1920, most of the businesses on West Union were automobile-related.

Carriage makers Turbett and Hovey had their business at the corner of DeLacy and Union, just one block north of West Colorado Street. Besides making, repairing, and painting carriages, they also painted signs, a special skill in the era before mass advertising and manufactured signs. By 1920, the company listed themselves as auto painters.

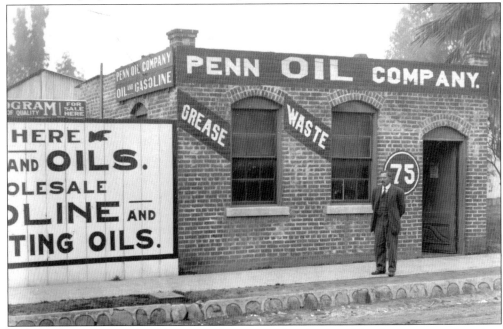

In the early 1900s auto-related businesses began to replace livery stables, feed stores, and carriage shops along Union and Green Streets. One example was this Penn Oil Company store at Union and DeLacy, which located here in 1906. By 1920, the company was also selling tires and other auto accessories.

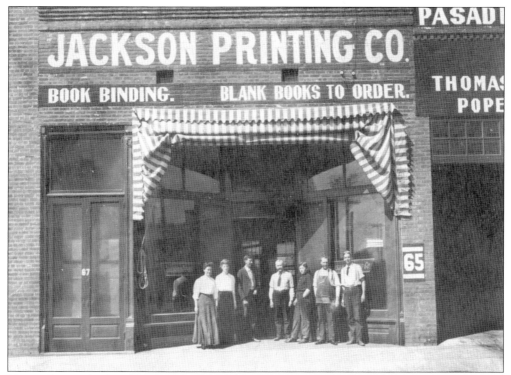

Union Street also became a center for Pasadena's printing trade. Several printing companies concentrated there, including Jackson Printing at 65 West Union. In the 1890s, the company had been located in a building on North Fair Oaks Avenue, just north of Colorado Street, which had probably become too expensive and too cramped for their expanding business.

Located at Green Street and Vernon Avemie, Crown City Manufacturing Company was one of the largest construction businesses in town. The company operated a planing mill, also manufacturing doors and windows, interior finishes, and mouldings for the many buildings going up all over Pasadena. In this photograph, Crown City workers proudly display a section of paneling mounted on a company wagon.

Frank Merritt stands in front of his Stair and Job Shop at 27 West Green Street in about 1906. Merritt advertised himself not only as a stair builder, but also as a construction contractor, carpenter, and pattern maker.

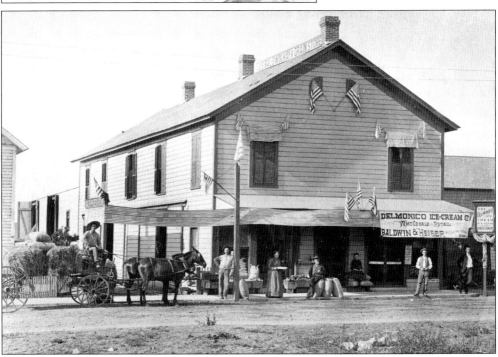

South of Green Street and west of Central Park were a number of small streets lined with cottages and small businesses. Just east of Fair Oaks Avenue at 24 Vineyard Street, J. S. Baldwin ran the Baldwin Stables. Baldwin and his family lived on the premises, probably in the second story. The building also had an ice cream shop, selling Delmonico Ice Cream. (Photograph by Reed.)

The Los Angeles & Salt Lake Railway station (later the Union Pacific station) was located on West Colorado Street at the northwest corner of Pasadena Avenue. From this depot trains ran north to Salt Lake City, but there was no direct line to the large Midwestern cities. This station had much less passenger traffic than the Santa Fe station on South Raymond Avenue.

As automobiles began to replace the horse and buggy, livery stables and feed and fuel stores were often converted into garages, but they continued to sell coal and wood as they had before. H. R. Slayden at 237 West Colorado, shown here in about 1915, had a gas pump located conveniently at the curb and a large door to bring cars in and out of the garage.

West Colorado was a favorable location for auto dealerships, This photograph shows the north side of Colorado Street, west of DeLacy Avenue in the early 20th century. At the far left is the Wood and Jones printing company building, at the far right a partial view of an early auto garage. All of the buildings in between have been extensively remodeled and rebuilt since this photograph was taken.

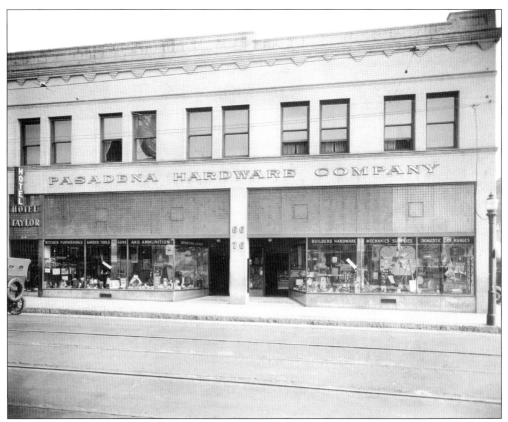

After 27 years occupying the lot at 13 East Colorado Street, Pasadena Hardware relocated to a new brick building on the southeast corner of Colorado and DeLacy Avenue in 1910. The new store, designed by builder Matthew Slavin, matched a similar new structure across the street. In the same year, the Model Grocery opened its main store in the same building, east of Pasadena Hardware. (Photograph by Hiller and Mott.)

By 1921, the Model Grocery had moved its main store from West Colorado Street to this new building on Colorado, east of Marengo Avenue. The company built its reputation on service, providing two city-wide deliveries a day at no extra charge and publishing catalogs every six months. In its heyday, 90 percent of its business was by delivery.

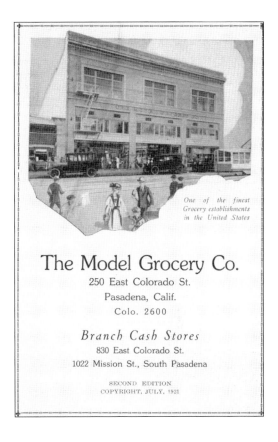

One of the finest Grocery establishments in the United States

The Model Grocery Co.

250 East Colorado St.
Pasadena, Calif.
Colo. 2600

Branch Cash Stores

830 East Colorado St.
1022 Mission St., South Pasadena

SECOND EDITION
COPYRIGHT, JULY, 1921

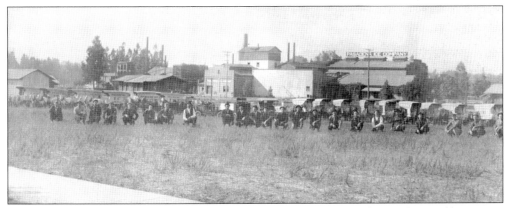

The Pasadena Ice Company built its first plant, an icehouse, stable, and office designed by Greene and Greene, in 1902 next to the railroad on Broadway (now Arroyo Parkway). The company revolutionized the ice industry by drawing water from deep wells under its plant and distilling it to manufacture ice. By 1915, it was one of Pasadena's biggest industries, delivering ice throughout the Los Angeles region. This photograph shows drivers and wagons in front of the company's buildings. (Photograph by E. W. Smith.)

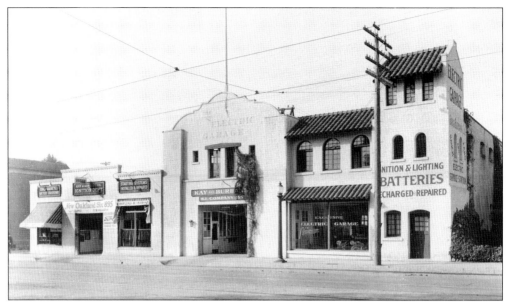

Myron Hunt and Elmer Grey designed this handsome Mission Revival–style building for the Star Saddle Livery in 1906. It reflects Grey's search for an appropriate architecture for California, which he said should use "low-pitched roofs and broad masses, thick masonry walls and consequent deep window and door recesses." By 1912, the building had been converted to auto uses. It still stands on South Fair Oaks Avenue across from Central Park. (Photograph by Frederick W. Martin; courtesy California History Room, California State Library.)

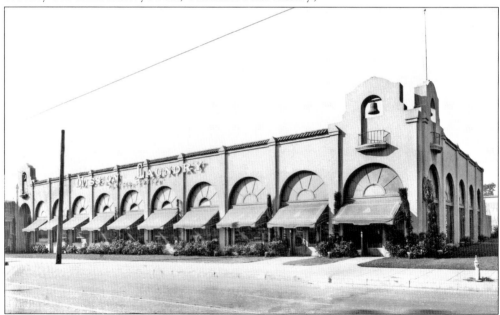

The district south of Central Park also had a number of large laundries. In the early days, women in need of money took in laundry, but by the early 1900s, industrial laundries began appearing. In Pasadena these buildings often had distinctive architecture and landscaping. Mission Laundry on South Raymond Avenue, built about 1924, was one of half a dozen in the area. (Photograph by Hiller Studios; courtesy Pasadena Public Library.)

Nine

EASTWARD EXPANSION AFTER 1900

By the early 1900s, large churches were locating along Marengo Avenue, creating a so-called "avenue of churches," and small hotels and boardinghouses along the street and along Colorado Street created a so-called hotel district. The construction of Pasadena High School in 1904 near Wilson School on Walnut Street east of Marengo created a "school district" nearby.

The construction of the Hotel Maryland on Colorado two blocks east of Marengo, and its incorporation of nearby small hotels into its property, gave added impetus to the expansion of retail trade along the street, which was frequented by tourists. The Maryland occupied a special place on the Pasadena hotel scene, since it was open year-round. This made it a center of Pasadena social life, and the elegant shops behind its famous pergola drew residents and visitors alike as customers.

This stringing out of Pasadena's downtown along Colorado threatened the old core around Colorado, Fair Oaks and Raymond. Yet it was a natural result of the layout of Pasadena's street system, which had few east-west through streets and many north-south ones. It was also a result of Colorado being part of a main auto route from the east to Los Angeles, which encouraged businesses to locate along it to attract passing traffic.

Pasadena's commercial buildings grew increasingly modern. The use of steel-frame construction allowed taller structures, bringing office buildings with elevators to the major intersections along Colorado and to North Raymond. Reinforced, poured concrete also enabled new forms of construction, particularly types using arches and domes to span greater distances. The Colorado Street Bridge and the Christian Science Church are notable early examples of reinforced concrete architecture in Pasadena.

Notable local architects, including Myron Hunt (1868–1952) and Elmer Grey (1871–1963), joined Roehrig in building Pasadena. All three of these architects, along with John Parkinson from Los Angeles, designed many of the larger buildings as well as residences of turn-of-the-century Pasadena. Although based in Pasadena, they had offices in Los Angeles and built throughout the region. Roehrig designed the 1904 Presbyterian church. Hunt and Grey, working together, completed the mansion for Henry Huntington (1910) and Throop Hall (1912) for Caltech on the current campus on California Street. Hunt also designed the new Maryland Hotel after the destructive fire of 1914. In the same year, the new Huntington Hotel opened, redesigned with additions by Hunt from the earlier building designed by Charles Whittlesey. John Parkinson of Los Angeles had designed the original Maryland (1903), as well as two major downtown office buildings, the Chamber of Commerce Building and Citizen's Bank.

The Chamber of Commerce Building, shown here from the rear under construction in 1906, was the first steel-frame building in the downtown. Built just east of the railroad tracks, and extending west to Broadway (now Arroyo Parkway), it set the tone for later large office buildings along Colorado Street in the 1920s. It was also set back to allow for the future widening of Colorado Street.

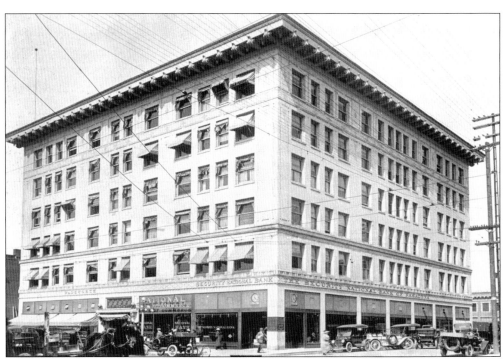

The Chamber of Commerce Building was remarkable not only for its six-story height, but also for its large footprint. Built in a U-shaped plan to allow a central light well for offices, the building was designed by Los Angeles architects Parkinson and Bergstrom. Only the heavy ornamental cornice and a restrained abstract pattern in colored terra-cotta and brick decorate the overall ochre brick exterior. (Courtesy Crowell Collection, Pasadena Museum of History.)

At about the same time, in 1906, Parkinson and Bergstrom designed a one-story building for Citizens' Bank in reinforced concrete at the northeast corner of Marengo Avenue and Colorado Street. In 1914, six stories were added, making it taller than the Chamber of Commerce Building. The first-floor exterior is beautifully decorated in glazed cream terra-cotta. (Courtesy Special Collections, University of Southern California.)

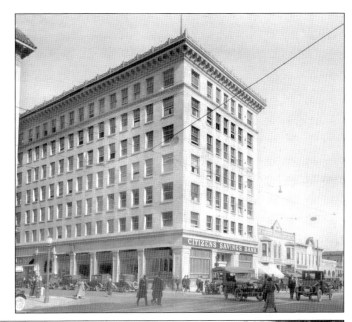

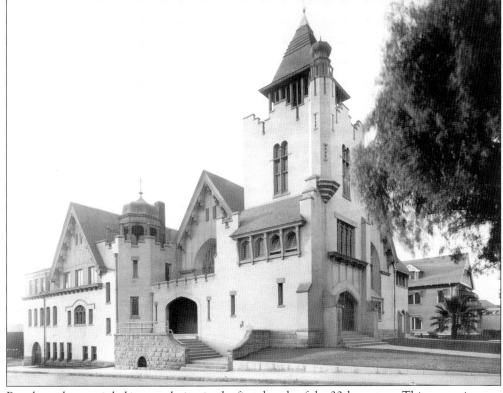

Pasadena almost tripled its population in the first decade of the 20th century. This expansion was reflected in the larger churches built near Colorado and in the neighborhoods east of Marengo Avenue, and in the many new schools. In 1903, Los Angeles architects Marsh and Russell designed this new First Baptist Church at Marengo and Union Street. (Courtesy Crowell Collection, Pasadena Museum of History.)

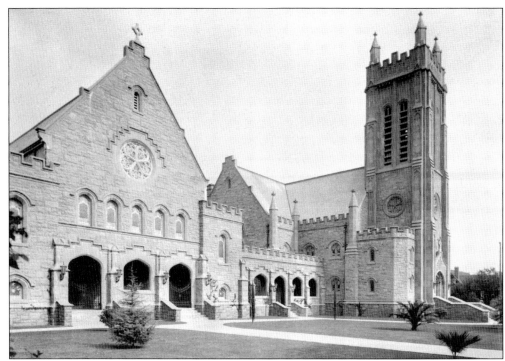

In 1904, the Presbyterians moved east to the northwest corner of Madison Avenue and Colorado Street. Architect Frederick L. Roehrig designed the stone Gothic-style building, which stood until the 1971 earthquake damaged it so severely that it was demolished and replaced by a new church building on the same corner. (Courtesy Special Collections, University of Southern California.)

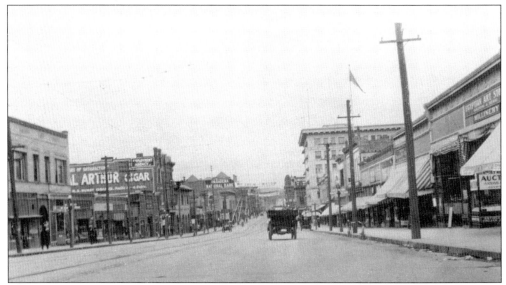

This view west on Colorado Street from Marengo Avenue in 1911 shows a thriving commercial district of one and two-story buildings, with the massive Chamber of Commerce Building jutting above smaller buildings on the right. It also shows the narrower street west of the railroad tracks, a condition remedied by the 1929 street widening.

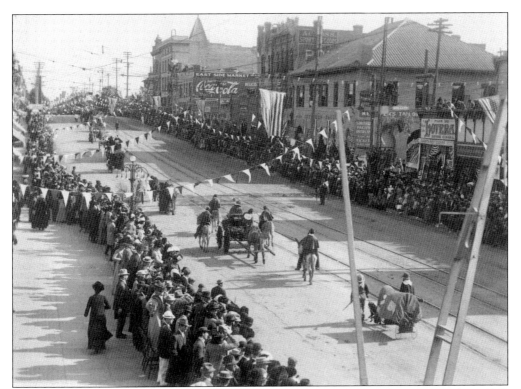

Looking east on Colorado from the railroad tracks, this photograph of the Rose Parade in 1912 shows a humbler, more home-grown version of the extravaganza that we see today. Behind the railroad-crossing barriers in the foreground is the tile-roofed depot of the Southern Pacific Railroad, the terminal for the Pacific Electric trolley system. The First Methodist church spire protrudes above the roofs of the commercial buildings. (Courtesy Giddings Collection, Pasadena Museum of History.)

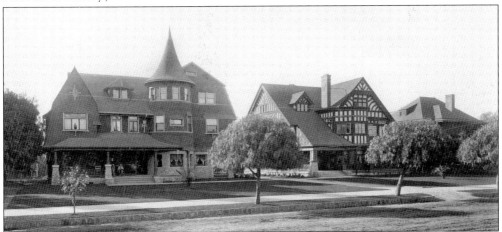

The residences built for the Vandervort brothers, Robert and John, at 482 and 494 East Colorado respectively, between Los Robles Avenue and Oakland Street, are typical of the grand mansions that once lined Colorado. Designed by T. William Parkes in 1893, one is in a restrained American Shingle style, while the other is an exuberant exercise in English half-timbering. (Photograph by William Henry Hill; courtesy California History Room, California State Library.)

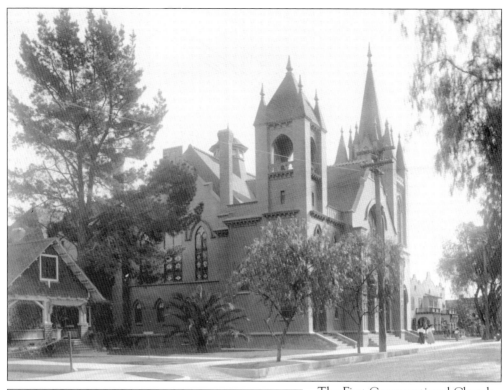

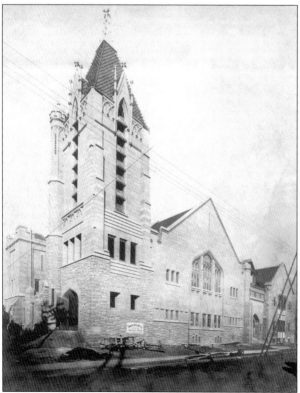

The First Congregational Church at Marengo Avenue and Green Street was the third of four churches built on Marengo near Colorado Street at the beginning of the 1900s, making Marengo the so-called "avenue of churches." A product of another split within the older First Congregational church on California Street over affiliation with the Unitarians, this church was finished in 1905.

At the northwest corner of Marengo Avenue and Walnut Street, the First Christian Church of 1907 was a substantial concrete and stone building. Their move east to Marengo from Fair Oaks put them on the "avenue of churches" and in a neighborhood of schools, with three schools just east of the church on Walnut. (Photograph by George Daskam; courtesy Special Collections, University of Southern California.)

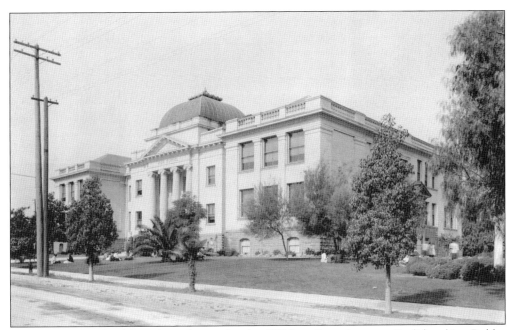

Pasadena High School (1904), on the north side of Walnut Street between Euclid and Los Robles Avenues, was an elegant Beaux Arts building with a domed rotunda and a portico of Ionic columns. Stone and Smith of San Francisco produced the winning design, besting 12 other architects who submitted plans for the $75,000 building. (California Historical Society Collection, University of Southern California.)

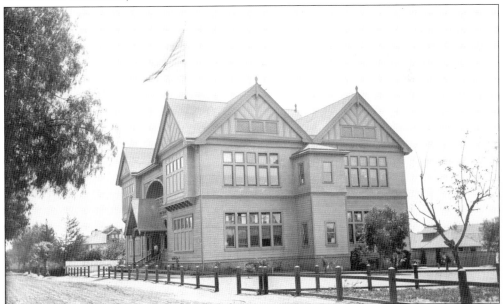

Benjamin Franklin School, built in 1887 as an annex to Wilson School on Walnut Street and designed by Ridgway and Ripley, served high school students in the 1890s. When the new high school opened across the street in 1904, Franklin became a primary school. Unfortunately the school burned to the ground soon afterwards, and the pupils were once again all crowded into Wilson. (Photograph by Hiller's Studio.)

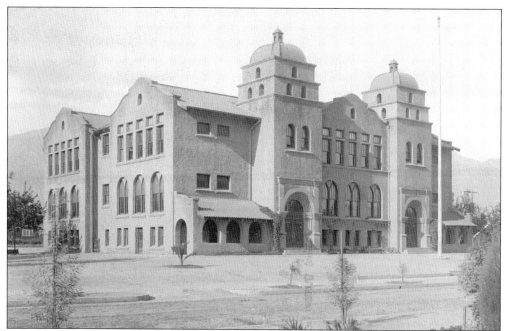

Before 1900, Pasadena had built neighborhood schools to serve outlying areas. After 1900, higher density neighborhoods close to downtown required larger, more substantial schools. Madison School, built in 1905 at Los Robles and Ashtabula Street, was a design of "the purest Mission type" by local architect Frank S. Allen. As soon as this school was finished, it was already overcrowded.

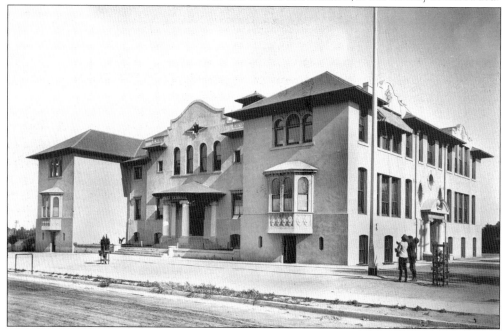

A more modest example of the Mission Revival, McKinley Elementary School, built in about 1903, was located on Del Mar Street near Lake Avenue to serve the southeast part of town. Architects Stone and Smith of San Francisco, who designed the high school, also rendered this design. (Photograph by C. C. Pierce, University of Southern California.)

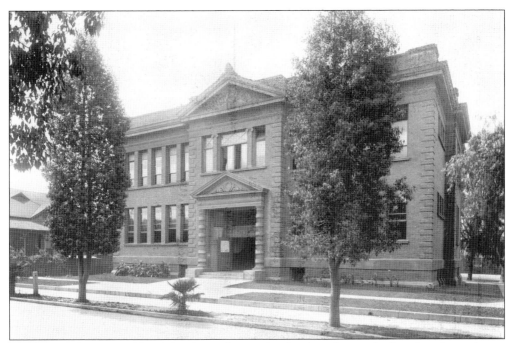

A substantial new Franklin School was designed in brick and stone by Los Angeles architect W. J. Bleisner to replace the old one, destroyed by fire in May 1904. This centrally located building on Walnut Street and Euclid Avenue later served as the headquarters of the board of education.

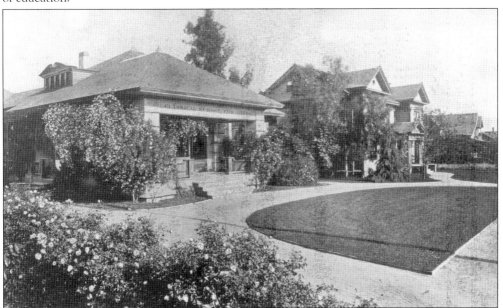

Pasadena had a number of private schools. One of the best known was the Orton Classical School for Girls on South Euclid Avenue near Green Street. The school specialized in preparing girls for eastern colleges. This photograph shows the main building in the foreground and the dormitory building in the background. The dormitory building, designed in 1900 by Frederick L. Roehrig, still stands.

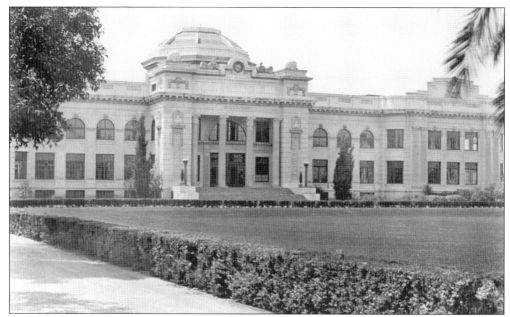

Pasadena's most ambitious school project was building a high school campus of three buildings "out in the country" on Colorado Street east of Hill Street. In 1910, crowded conditions had forced the school district to lease the old Throop building on North Raymond as a high school. This photograph shows the main building, opened in 1913 and named for educator Horace Mann. (Courtesy Crowell Collection; courtesy Pasadena Museum of History.)

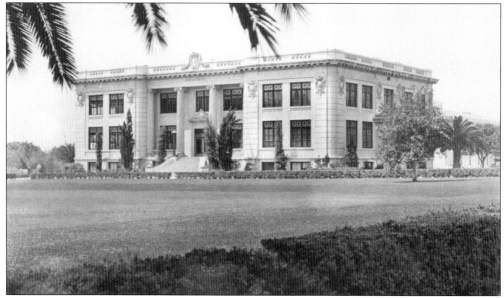

The high school's Jane Addams Building was named for the famed Chicago social worker. Addams (1860-1935) founded Hull House, a settlement house in the slums of Chicago in 1889, to alleviate the suffering of immigrants. Hull House also became a laboratory for investigating the social ills of the time. Addams's experiences led to new ideas regarding the role of women and for reforming society. It was highly unusual to name a high-school building after a woman, let alone a woman still living. (Courtesy Crowell Collection; courtesy Pasadena Museum of History.)

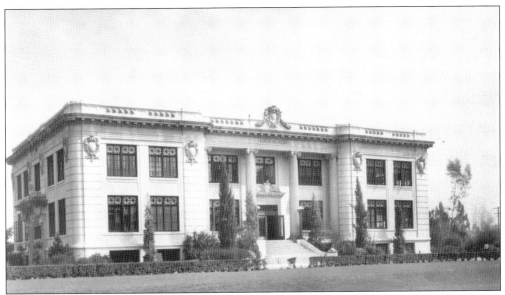

The third high school building was named for biologist Louis Agassiz and was outfitted with laboratories to serve the science classes. In 1924, Pasadena established a junior college, and eventually the high school campus became the home of Pasadena City College. All the buildings, originally designed by Norman F. Marsh, were remodeled extensively after the Long Beach earthquake in 1933. (Photograph by Frederick W. Martin.)

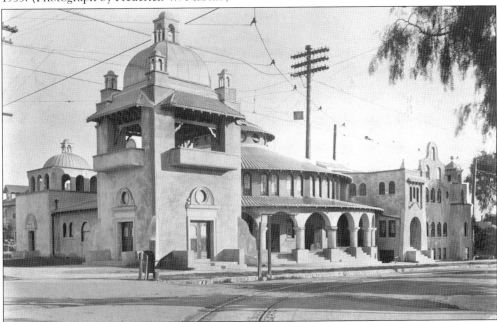

Lake Avenue Methodist Church was also "way out in the country" when it opened in April 1907 at the southeast corner of Colorado Street and Lake Avenue. Architect J. Cather Newsom of San Francisco designed this striking Mission Revival building with a curved facade reflecting the auditorium style seating favored by the Methodists. Replaced in the 1920s with a multistory bank building, the church once stood at what is now Pasadena's major downtown intersection. (Courtesy California Historical Society Collection, University of Southern California.)

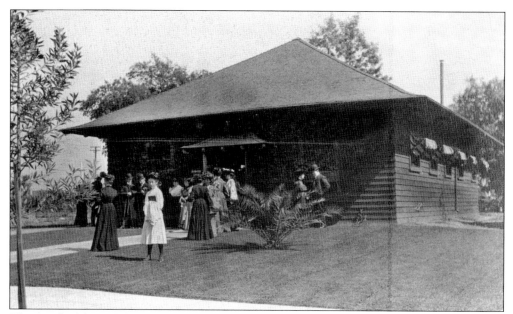

The first building of the Christian Science church, located at Colorado and Oakland Streets in 1903, was a Craftsman-style structure. Enlarged in 1905, it still could not accommodate the growing congregation. That same year, the church purchased property at Oakland and Green Streets, and work began on one of the largest buildings in town. (Courtesy Security Pacific Collection, Los Angeles Public Library.)

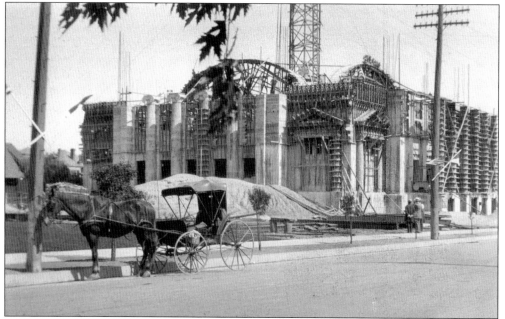

The Christian Science church was built of reinforced, poured concrete, the first large building in Pasadena to use this method. Construction began in 1906, and local architect Will Benshoff chronicled its progress in a series of photographs. In this photograph, the horse and buggy in the foreground contrast with the huge modern derrick and the massive wood forms built to receive the poured concrete. (Courtesy Benshoff Collection, Pasadena Museum of History.)

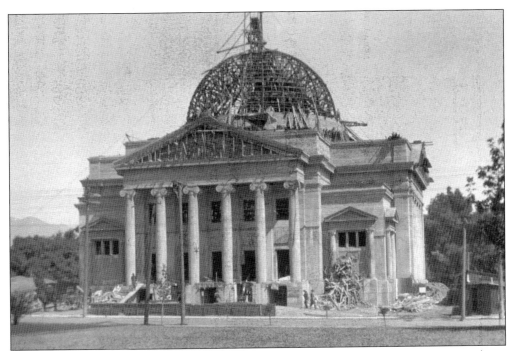

A second photograph by Benshoff, viewing the Christian Science church from the west, shows the completed framing for the dome surrounded by piles of timber removed from the hardened concrete. (Courtesy Benshoff Collection, Pasadena Museum of History.)

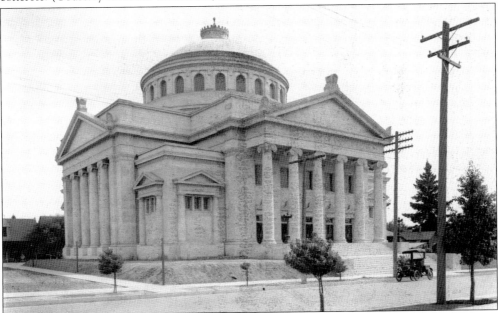

The First Church of Christ Scientist still stands as a dominant feature in its part of downtown. Designed by Los Angeles architect Franklin P. Burnham to seat 1,400 people, it cost over $100,000 to build. With its large dome and columned porticos on all four sides, the building was called "Corinthian" style at the time, but it actually resembles Palladio's Villa Rotonda. (Courtesy California Historical Society Collection, University of Southern California.)

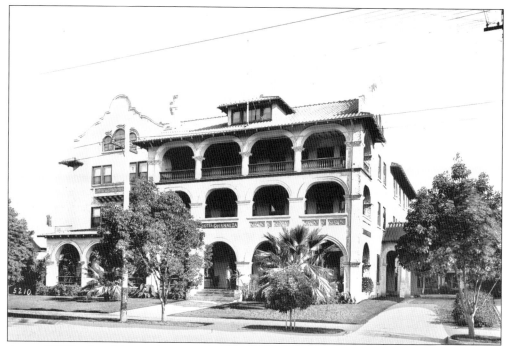

Around 1900, a hotel district began to develop east of Marengo Avenue. Pasadena was attracting more visitors and needed more accommodations for them. These small hotels and boardinghouses were either purpose-built or converted from large houses. The Hotel Guirnalda, next to the First Methodist church on Colorado Street, was one of the larger of the former type. A handsome Mission Revival–style building, it opened in 1900, advertising 50 bedrooms. (Courtesy California Historical Society Collection, University of Southern California.)

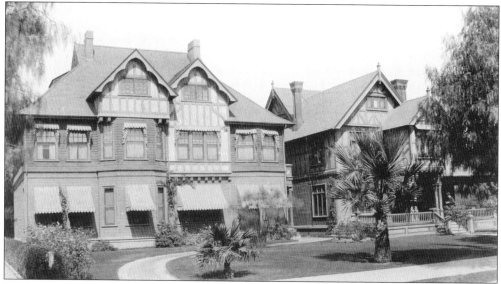

La Casa Grande, a complex of Tudor-style buildings on the northeast corner of Euclid Avenue and Colorado Street, had been run as a small hotel since 1894. Purchased in 1902 by D. M. Linnard, future Pasadena hotel magnate, the property was integrated later into the Maryland Hotel. (Photograph by Graham and Morrill.)

The Hotel Spaulding began as a boardinghouse on South Marengo Avenue and expanded into a small hotel on Colorado Street, between Worcester (now Garfield) and Euclid Avenues. In 1904, Linnard bought the Spaulding to run it as part of the Maryland Hotel. The purchase gave the Maryland complete control of two blocks on East Colorado. (Photograph by J. Hill.)

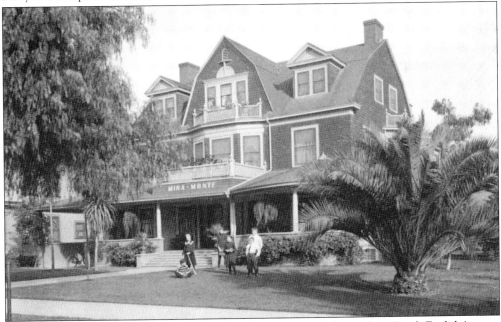

The Mira Monte, a large boardinghouse built in the 1890s, was located on South Euclid Avenue near Green Street. It was demolished in the 1920s to accommodate the extension of Green and the new civic center.

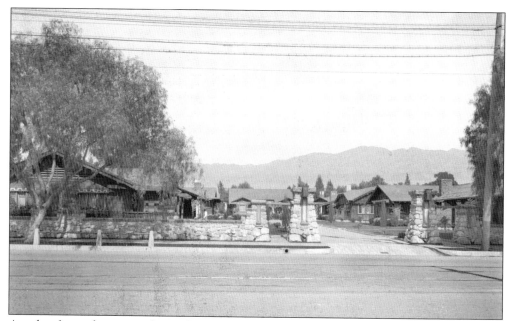

Another form of accommodation for tourists was the bungalow court, a housing type first seen in Pasadena. The earliest was St. Francis Court, designed in 1910 by Pasadena architect Sylvanus Marston and located on the north side of Colorado Street between Oak Knoll and Hudson Avenues. A wall and gate marked the entrance to the court, setting it off from its neighbors. (Courtesy California Historical Society, University of Southern California.)

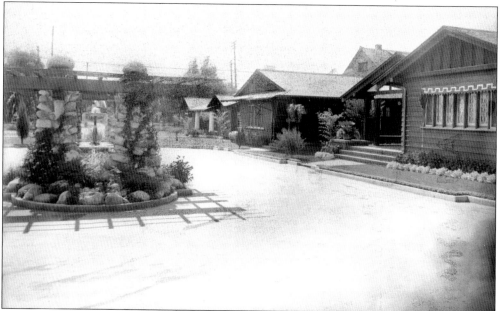

Small bungalows grouped around a central courtyard provided privacy, yet were more economical to rent than a house. Bungalow courts became popular for permanent residents as well, offering low rents and easy access to the outdoors. Displaced by commercial development, some St. Francis Court bungalows were moved to South Catalina Avenue, where they now make fine single-family houses. (Courtesy California Historical Society, University of Southern California.)

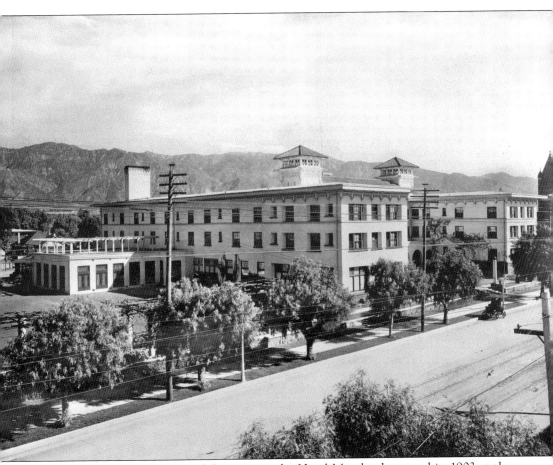

The center of the downtown hotel district was the Hotel Maryland, opened in 1903 at the northeast corner of Colorado Street and Los Robles Avenue, with 150 rooms. Built for owner Colin Stewart, who had come to Pasadena in 1897 from Baltimore, it was designed by John Parkinson and reportedly cost $100,000. Besides catering to tourists, the Maryland soon became the center of Pasadena's social life, as it was the only hotel to remain open year round. D. M. Linnard, who bought the hotel within three months of its opening for $215,000, boasted that he had "thrown away the key." Shortly afterward, Linnard hired architect Myron Hunt to design a pergola and formal garden for the hotel. Hunt, newly arrived in California, later designed two new wings for the hotel, adding about 250 rooms in 1908. (Courtesy California Historical Society, University of Southern California.)

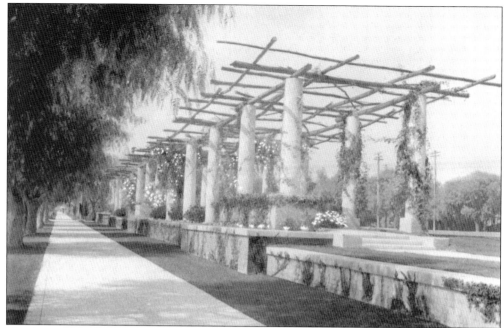

Hunt's pergola of stark classically proportioned concrete columns without capitals or bases, linked by unpeeled eucalyptus branches across the top, was a dramatic combination of the modern and the rustic. Behind the pergola lay a formal garden with a sunken pool with water lilies, based on Italian and Spanish models, as well as on Bertram Goodhue's Gillespie estate in Santa Barbara.

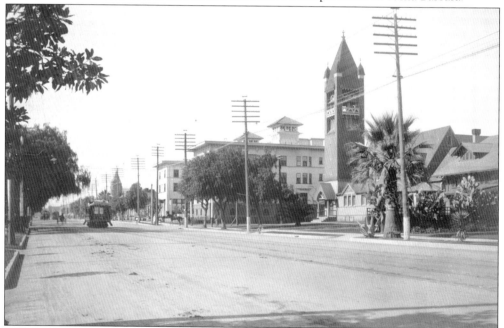

This view of the Maryland Hotel from the southeast in about 1910 shows the streetcar line on Colorado Street, the United Presbyterian Church in the foreground, and the tower of the 1886 First Presbyterian church in the background. (Courtesy Ninde Collection, Pasadena Museum of History.)

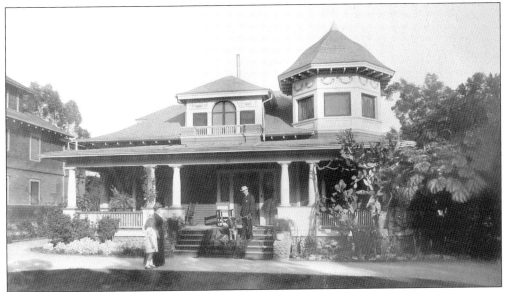

Linnard pioneered the idea of bungalows attached to his hotel. At first, he acquired nearby houses and rented them out to seasonal guests who enjoyed full hotel privileges. Later he built new bungalows north of the hotel, creating the Maryland's famed "Bungalowland." This bungalow, No. 90, a Victorian house appropriated by the hotel, bears no resemblance to a "bungalow" in the conventional sense.

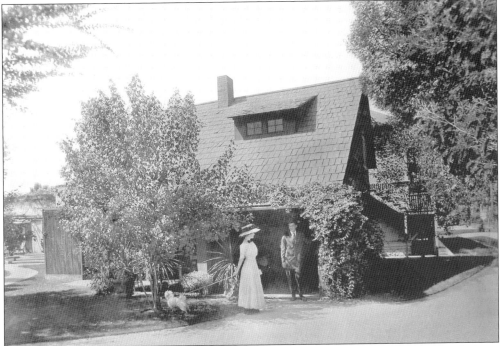

A photograph of Bungalow No. 80½ shows the park-like grounds and gives a glimpse of a later, stucco bungalow in the background on the left. The picture also advertises the social advantages of hotel life. Families brought their daughters and sons of marriageable age to participate in the social events of the hotel, hoping to make a favorable match.

Hidden in a grove of trees, Bungalow No. 66 looks as though it is situated in a rustic camp, not in the middle of a growing city. Above, ladies in long dresses enjoy a quiet afternoon on the shaded patio, while the canvas porch swing, left, provides an ideal place to read or nap.

Myron Hunt designed several bungalows on the Maryland hotel grounds. His pergola design at the front of the hotel was adapted to create a shaded sitting area in front of Bungalow No. 75. In this photograph, guests enjoy a glass of punch or lemonade on a warm afternoon.

The cover illustration of the bungalow catalog, a collection of photographs that guests could leaf through to select a bungalow, typifies the genteel, romantic image the hotel used to attract customers at the beginning of the 20th century.

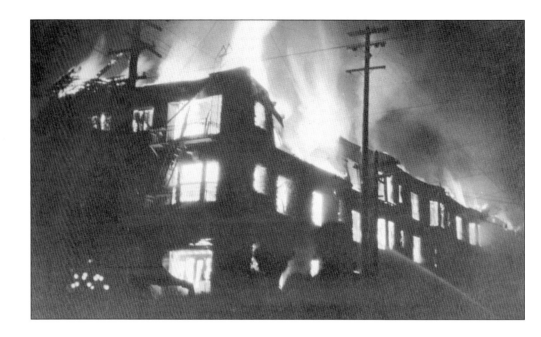

On the night of April 18, 1914, a devastating fire struck the Hotel Maryland. Guests were warned in time to escape, and some threw their luggage out the windows. The morning of April 19 revealed the smoldering ruins of the hotel. The building was not completely destroyed, as part of the east wing remained standing. Myron Hunt, a resident of the hotel since the death of his wife, also escaped. Reportedly he began drawing plans for the new hotel immediately.

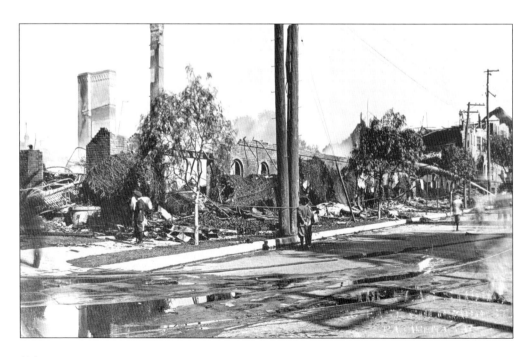

The new Maryland was virtually indistinguishable from the old in exterior design. The old pergola was rebuilt, but now it was integrated into the commercial district that was rapidly surrounding the hotel. One side of the pergola was lined with shops that were part of the hotel. The view below shows how the pergola formed an inviting entrance to the exclusive shops behind it.

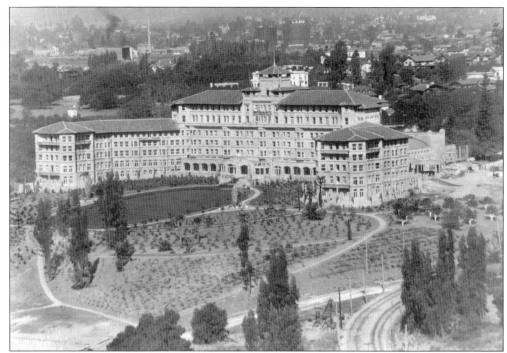

In 1914, the Huntington Hotel opened in the exclusive Oak Knoll district, with D. M. Linnard as manager. Opened as the Hotel Wentworth in 1906, it had closed after one season, partially finished and plagued by cost overruns. Myron Hunt redesigned the building and completed two upper stories for Henry Huntington, the new owner. As the newest and most luxurious hotel in Pasadena, the Huntington competed with downtown hotels for business. (Photograph by Bach; courtesy *Herald-Examiner* Collection, Los Angeles Public Library.)

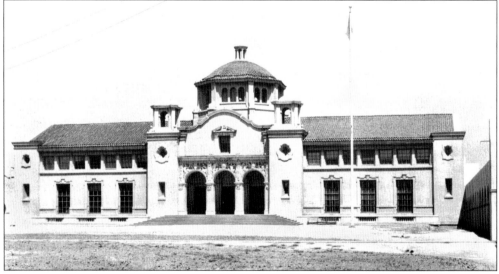

Throop Institute left downtown in 1912 for its new campus amid orange groves on East California Street. Myron Hunt and Elmer Grey completed a campus plan in 1908, and the first building, Throop Hall, in 1909. Sculptor Alexander Stirling Calder created the allegorical figures over the entry arches. (Courtesy Crowell Collection, Pasadena Museum of History.)

The founding of the Huntington Library in the 1920s enhanced Pasadena's cultural image, although it was actually located in neighboring San Marino. Henry Huntington's house, built just south of the Throop campus in 1910 from a design by Hunt and Grey, became the nucleus of a major institution that would draw visitors to Pasadena even after the era of the great hotels had passed.

In 1920, Myron Hunt and H. C. Chambers designed a library building for Henry Huntington. The library became the core of the major research institution founded by Huntington, largely at the instigation of astronomer George Ellery Hale.

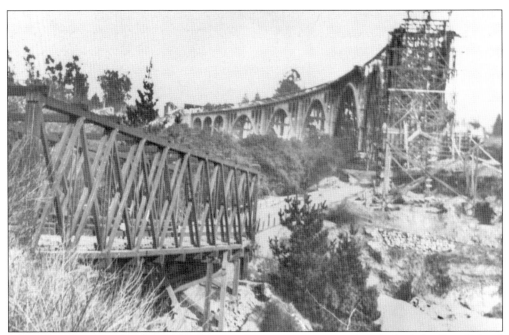

The Colorado Street Bridge, shown here under construction in 1912, linked the San Gabriel Valley with the San Fernando Valley and with West Los Angeles. Promoted by the Pasadena Board of Trade, the bridge made Colorado Street a major thoroughfare, bringing more traffic through the city and boosting businesses along the street.

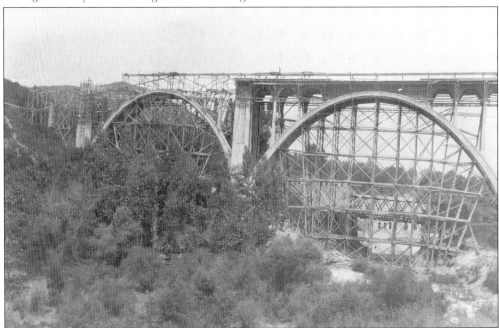

Progressing from east to west, skilled carpenters built wooden forms to receive the concrete prepared in a cement mixer on the eastern bank. A small railroad track across the top of the structure carried dump cars filled with concrete to the work location. Metal channels funneled the concrete down to workmen on the scaffolding who pressed the concrete into the forms.

A view of the finished bridge from the south shows the old Scoville Bridge behind it. Hailed as a "work of art" when it opened in 1913, the Colorado Street Bridge was also a major feat of engineering. A limited budget and the lack of solid footing in the Arroyo led to the unconventional solution of curving the roadway, producing a more pleasing design. (Courtesy Special Collections, University of Southern California.)

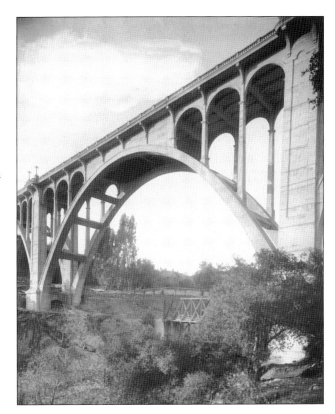

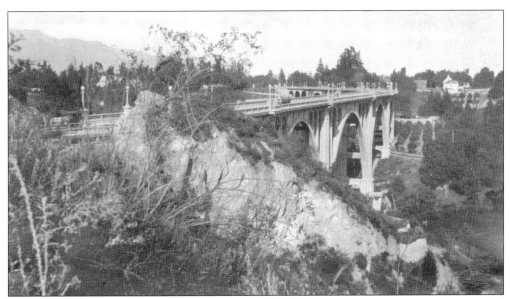

This view of the bridge from the west shows the curve of the span, orange groves in the bottom of the Arroyo, and houses on Grand Avenue on the eastern bank. Note the single-light lampposts that once illuminated the bridge at night.

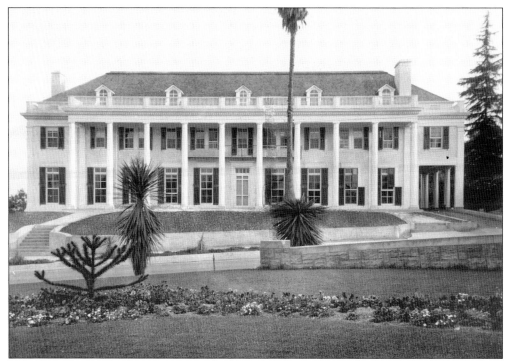

The plan for the Colorado Street Bridge encouraged more building on West Colorado. In 1911, Myron Hunt designed a new building on Colorado just east of Orange Grove Avenue for the local Elks lodge. A dignified Colonial Revival–style building, reminiscent of southern plantations, the Elks building still stands.

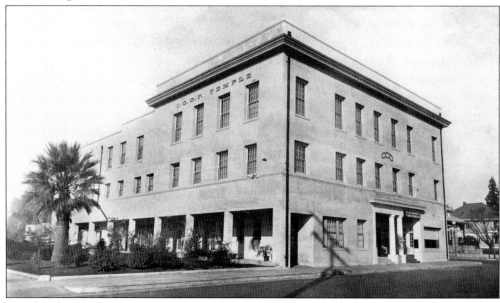

Another fraternal organization, the Odd Fellows, dedicated their new building, designed by Cryil Bennett, in 1917 on North Garfield Avenue just north of the new post office. In less than a decade, the new civic center plan would dominate the area, eventually forcing the Odd Fellows to move further east to Los Robles Avenue.

Ten

PASADENA'S CIVIC CENTER

A *Pasadena Plan*, published by the Women's Civic League in 1915, suggested ways to make Pasadena "a more beautiful and more useful city." One of many efforts at civic beautification, it proposed a civic center for public buildings at Library Park and a central station there for railroad and streetcar lines, with rail lines placed underground. The plan attracted attention, but it was too ambitious to be realized. Several of its ideas, however, would turn up again in the 1923 plan for Pasadena.

George Ellery Hale, the astronomer, was an energetic visionary who had come to Pasadena in 1904 from Chicago to set up Mount Wilson Observatory with Andrew Carnegie's money. By 1921, Hale had already completed the transformation of Throop Polytechnic Institute into the California Institute of Technology, modeled on his own alma mater, MIT. He also persuaded Henry Huntington to create a major research institution in arts and letters, the Huntington Library and Art Gallery. Hale dreamed of transforming provincial Pasadena into a fitting setting for these internationally known institutions. Drawing on his Chicago connections and his friendships with the late Daniel Burnham and with Bertram Goodhue, Hale persuaded Pasadena civic leaders to hire Bennett, Parsons, and Frost of Chicago, successors to Burnham's architectural and planning firm, to create a city plan for Pasadena.

The Bennett plan of 1923 proposed a civic center located at Colorado Street and Garfield Avenue, with major buildings on both sides of Colorado, and boulevards linking the civic center to the Colorado Street Bridge at the western entrance to the city. A new art museum, modeled on the Chicago Art Institute, was planned to mark this western entrance with a strong civic presence. Ten California architectural firms were invited to submit a design to compete for the award of three major civic buildings: a library, a city hall, and an auditorium. Jury members included Hale, Ernest Batchelder, architect John Galen Howard, and head of the planning commission Stuart W. French. Invited architects were the best that California had to offer: Allison and Allison; Johnson, Kaufmann, and Coate; Myron Hunt; Marston, Van Pelt, and Maybury; Bakewell and Brown; Robert D. Farquhar; Bliss and Faville; Bennett, Haskell, and Bergstrom; Willis Polk; and Carlton Winslow. Thanks to Hale's salesmanship, the civic center plan was largely realized, with the final building, Civic Auditorium, completed in 1932.

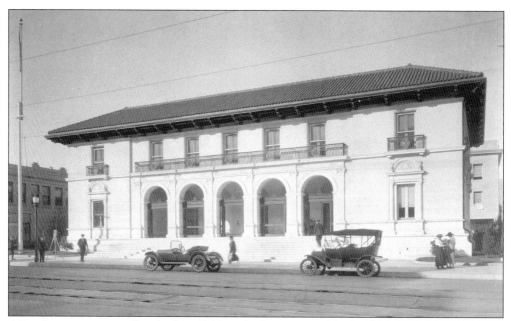

A handsome new post office, built in 1914 on the former site of the Presbyterian Church, became one of the focal points of Pasadena's plan for a new civic center in the 1920s. Designed by post-office architect Oscar Wenderoth in a Renaissance Revival style, the building featured the red-tile roof and white-plaster walls that defined the California Mediterranean style. Pasadena citizens paid for extra features, including the marble facade, bronze gates, an interior stained-glass skylight, and a Guastavino tile ceiling in the entry loggia.

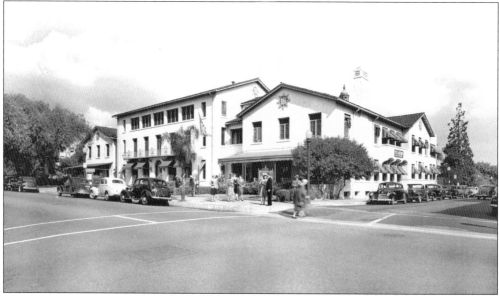

The YWCA built its new quarters just to the south of the YMCA on Marengo Avenue. Designed by California architect Julia Morgan in 1921, the new YWCA provided meeting rooms, bedrooms, and a large pool. The exterior, done in a subdued California Mediterranean style, featured arched French doors leading to a terrace across the front, a red-tile roof, and a rear courtyard enclosed by two wings of the building. (Photograph by J. Allen Hawkins.)

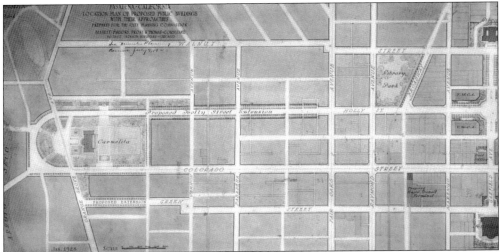

The plan focused on the new post office and the YMCA and YWCA buildings, centering the new city hall behind the Ys, facing west on Garfield Avenue, just north of the post office. The library and auditorium flanked city hall on the north and south respectively, facing each other and terminating the main axis, which is Garfield Avenue. The library and auditorium flanked city hall on the north and south respectively, facing each other and terminating Garfield at both ends. City hall terminated the Holly Street axis on the east. On the west, a new art museum was planned at the end of Holly Street in Carmelita Park, connecting the civic center to the Colorado Street Bridge and creating a grand ceremonial entrance into the city.

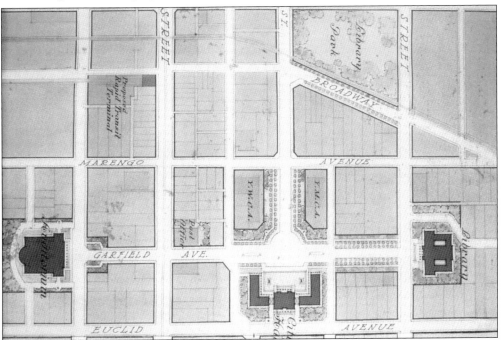

Public attention focused on building the three new civic buildings that were the cornerstones of the plan. The old library building had become inadequate for the growing city. Pasadena had no modern auditorium for concerts or meetings, and city government had outgrown its old city hall. Nine California architects submitted plans in competition for the three public buildings.

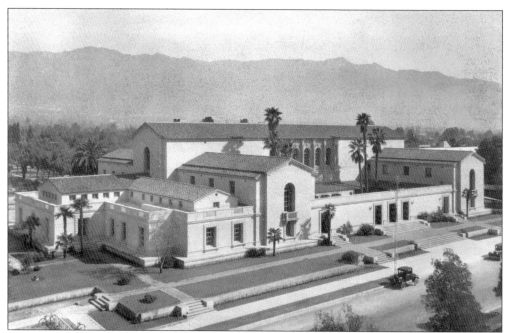

Myron Hunt was selected to design the library. Always conscious of landscape design and setting, Hunt graded the site to set the base of the building a few feet above the sidewalk, capturing valuable basement space with minimal excavation. He had mature palm trees set into the patio. Projecting above the roofs, they accentuate the horizontal lines of the design

Hunt's long low facade with projecting side wings enclose a charming entrance patio, with its splashing fountain, an invitation for library patrons to enjoy the generous new spaces within. Hunt planned for the library's inevitable need for more space, plans that have been followed in at least two expansions since the building opened in 1927. (Photograph by Harold A. Parker.)

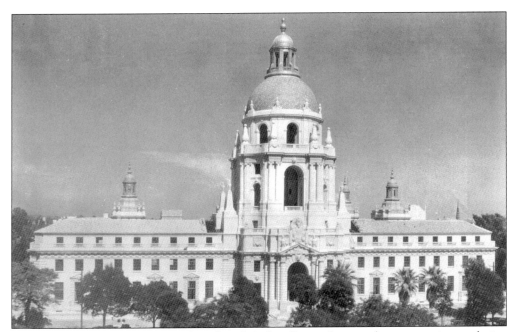

San Francisco architects John Bakewell and Arthur Brown Jr. won the competition to design Pasadena City Hall. As the architects of San Francisco City Hall, they were expected to provide a no less grandiose design for Pasadena. Pushed into designing a dome for the building by the demanding jury, the architects produced a light wedding cake-like structure in poured concrete.

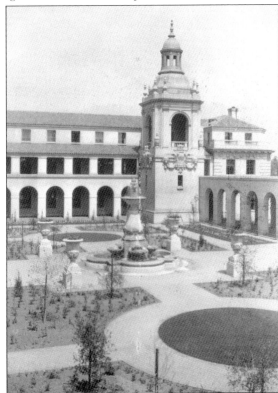

The genius of Bakewell and Brown's design, recognized by the jury, lay in the central garden enclosed by the building itself. Its focal point, a splashing fountain, animates the space, and its corner stairwells provide access to all the offices in the building. This early photograph shows the initial planting, inspired by Spanish and California Mission gardens.

Pasadena architects Marston, Van Pelt, and Maybury did not win the competition, but their buildings enhanced the new civic center. The firm adapted an existing garage to create this elegant, small office building on North Garfield Avenue for the William Wilson Company, a real estate firm. A frieze in *sgraffito*, an Italian plaster technique, decorates the building. City hall is on the left in this photograph. (Courtesy Marston Collection, Pasadena Museum of History.)

Perhaps taking his cue from the William Wilson building, the Southern California Gas Company architect used *sgraffito* panels between the second story windows on the utility's new building at Garfield and Ramona Avenues, completed in 1926. A red-tile roof, Renaissance-style arches, and lines cut into the plaster finish to simulate masonry joints evoke the architecture of Italy.

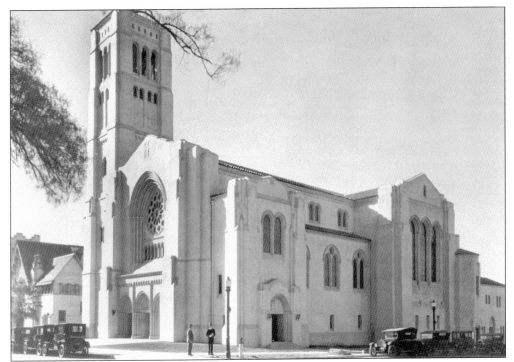

Architects Carlton Winslow and Frederick Kennedy Jr. did not win the civic center competition. However, their First Baptist church, at Marengo Avenue and Holly Street, is a major contributor to the overall plan. Winslow worked with Bertram Goodhue on the San Diego Exposition in 1915, where he learned to adapt historical elements for a new material, poured concrete. The starkly molded, modern lines of the church building stand out in the strong Southern California light. (Courtesy Crowell Collection, Pasadena Museum of History.)

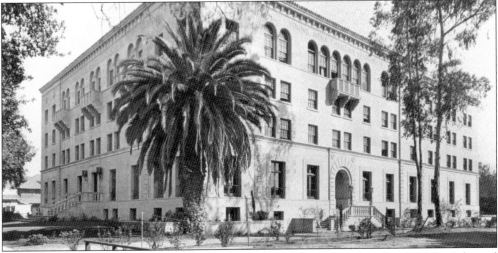

The YMCA remodeled its 1910 building in 1926 based on designs by Marston, Van Pelt, and Maybury, adding several feet to the south side of the building and reorienting the main entrance to the south. The stucco finish, arched entrance and windows, and upper-story balconies add up to a convincing Mediterranean facade to match the surrounding buildings. (Courtesy Crowell Collection, Pasadena Museum of History.)

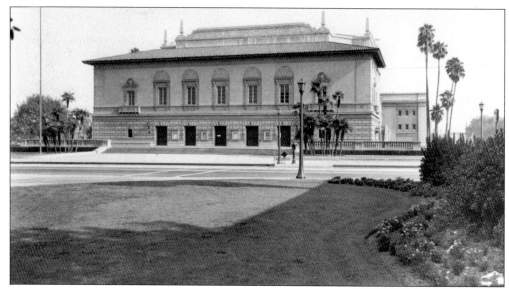

The last building to be finished, the auditorium, opened in 1932. Designed by Pasadena architects Cyril Bennett and Fitch Haskell with Edwin Bergstrom of Los Angeles, the auditorium is an adaptation of a Renaissance *palazzo*, ornamented by colored tiles above the upper-story windows. The approach to the building on Garfield Avenue opened out into small parks on each side of the street, enhancing the setting of the building.

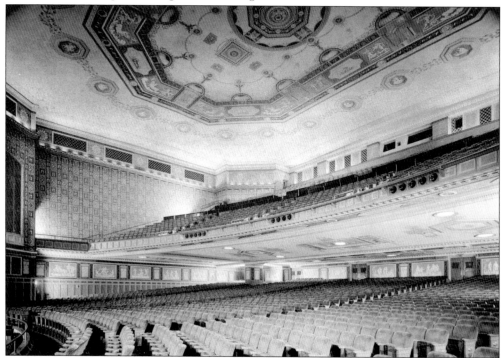

The auditorium's interior features a splendid ceiling ornamented with stucco work and painted designs, as well as walls painted in *trompe l'oeil* designs above, and panels of classical figures painted in *grisaille* below. Besides the main auditorium space, the building has a smaller hall upstairs for more intimate performances and an exhibition building behind the main stage.